TAPESTRIES AND MOSAICS
OF MARC CHAGALL
AT THE KNESSET

TAPESTRIES AND MOSAICS OF MARC CHAGALL AT THE KNESSET

By
Ziva Amishai-Maisels

with a foreword by
Israel Yeshayahu, Speaker of the Knesset

TUDOR PUBLISHING COMPANY
NEW YORK

Leon Amiel expresses his deep gratitude to Madame Vava Chagall for the inestimable help she has given in compiling this work, to Marc Chagall for his kindness in authorizing it to the Knesset for its valuable assistance, to Charles Sorlier in supervising the publication, to the author and finally to all the technical collaborators, in particular to Fernand Mourlot without whom it would not have been possible to produce a work of this quality.

Library of Congress Cataloging in Publication Data
Amishai-Maisels, Ziva, 1939
Tapestries and mosaics of Marc Chagall at the Knesset.
I. Chagall, Marc, 1887 · II. Israel. Knesset.
III. Title.
NK3056.A3C452 · 915.694'8 · 73-12270
ISBN 0-8148-0567-1

Printed in France

CONTENTS

LIST OF ILLUSTRATIONS

ON a hill-top, previously called *Givat-Ram*, on the western border of Jerusalem, stands the Knesset building, the seat of the elected Parliament of the independent State of Israel, a symbol of her sovereignty and an expression, in theory and in practice, of her enlightened democratic government.

Surrounding the Knesset and its hills the "City," the "Kiryah," has come into being, "a royal city, seat of the kingdom." It includes not only government office buildings, but, on one side, the campus of the Hebrew University and, on the other, the Israel Museum complex. The wise architects created here, intentionally or not, a beautiful and meaningful synthesis of governmental authority, wisdom and art in their modern, enlightened sense.

From the "Kiryah," we can gaze upon a heavenly pano-rama: a wall of hills, gently rising and falling, crossed by asphalt highways and covered by tall trees standing erect in scattered groups like congregations or "minyans" of praying Jews.

At some distance, beyond the range of the human eye, but very close to the heart, at the eastern edge of Jerusalem, are located the historical holy places: the site of the Temple, the remnants of the past glory of the Jewish people, among which stands, first and foremost, the Western Wall. There too the holy sites of Christianity and Islam are centered. There everything the eye can see or the hand touch, above ground or beneath it, is ancient and historical, whether archeologists have already uncovered it or whether it lies still buried in the secret recesses of the earth.

And, in the space between the old and the new, between holiness and faith and secular modern life, lies the city of Jerusalem, its houses and neighborhoods, markets and institutions, schools and synagogues and the vast population living within its bounds.

The Knesset building is modest and low from the outside, but splendid and proud within—a perfect paradigm of the essence of the Jew throughout the ages. Inside the Knesset, in its heart of hearts, two rooms act as magnets continually drawing hundreds of thousands of "pilgrims," Israelis and tourists from all over the world, Jews and non-Jews alike, including tens of thousands of Arabs from neighboring countries, despite the fact that these states are still at war with Israel. These two focal points are: the Assembly Hall, in which the nation's representatives sit in a semi-circle like the ancient Sanhedrin, and the State Reception Hall, decorated with the marvelous works of the great Jewish artist Marc Chagall: the Gobelins tapestries adorning the western

wall of the hall; the mosaic depicting the Western Wall, set here into the northern wall; and the twelve mosaic fragments embedded into the floor.

This is not the place to enlarge on Chagall's biography or on his artistic character, which is as many-sided, varied, and rich in content as are his paintings. Neither shall I dare to explain here the meaning of his works in the Knesset—that should be done by experts and art critics. But as one of the viewers of these works, I would like to say that they stimulate the imagination, attract the eye, and conquer the heart. This is the secret power of a creative genius whose artworks produce in us an emotional state which binds us to them. The more you gaze at his work, the stronger grows the spiritual bond between you, even though you cannot explain this tie or interpret it rationally.

The main point, but not the only one, which must be stressed, is the successful mating—if one may put it thus—between Chagall and the Knesset. It goes without saying that if a parliamentary building was erected in Israel and if it contained a reception hall in which state ceremonies and celebrations were to take place, it had to be decorated with art of the highest possible quality.

In the book of "Exodus," we are told that God spoke to Moses, pointing to Bezalel the son of Uri, the son of Hur, who was "wise-hearted" and a great artist, who knew how to "think and devise skillful works, to work in gold, and in silver, and in brass," and was therefore worthy to execute the work on the sanctuary and on the ritual utensils.

Who in our generation is wise-hearted, and knows how to think and devise skillful works, who could rise up and execute the decoration of the Knesset's reception hall? Obviously: Marc Chagall.

While the Knesset building was being erected, the late Kadish Luz, of blessed memory, was the Speaker of the Knesset. Born in Bobroisk, he was one of the founders of Kibbutz Deganya and a leader of the kibbutz movement in Israel. Marc Chagall was born in Vitebsk and is a creative artist of international renown whose works decorate some of the most famous and important cultural centers in the world. Both men, Kadish Luz and Marc Chagall, had the same physical and spiritual birthplace: Jewish towns in the Pale of Settlement in Russia, with their distinctive landscape and atmosphere at the end of the nineteenth and the beginning of the twentieth centuries.

The landscape and way of life of these two towns left a deep impression on the souls of both these men, and one can even say that they molded their creative and spiritual characters. On this subject, the late Kadish Luz said:

Vitebsk and my Bobroisk, two cities in the Pale of Settlement, were like twin sisters, most of whose population was Jewish. Even now I sometimes dream of Bobroisk, its Jews and synagogues, its stores, rabbis and cart-drivers. The atmosphere of these cities was saturated with the Bible, the Jewish past, legends, jokes and tunes, as well as the deepest poverty. . .

In like manner Chagall has said: "The earth that nourished my soul was Vitebsk" and "The doubt and dreams that oppressed me sometimes in my native city arose anew and deprived me of my rest."

Describing the way of life in his parent's house, in his native town at the beginning of his development, Chagall wrote:

"If my art played no part in my family's life, their lives and their achievements greatly influenced my art. You know, I was greatly excited as I stood beside my grandfather's seat in the synagogue. Poor wretch, how I twisted and turned before I got here! Facing the window, my prayer book in my hand, I gazed at leisure on the sights of Lyozno [a place near Vitebsk], on the Sabbath. . . - Behind my back, they are beginning the prayer and my grandfather is asked to intone it before the altar. He prays, he sings, he repeats himself melodiously and begins over again. It is as though an oil mill were turning in my heart! Or as though a new honey, recently gathered, were trickling down inside me. And, when he weeps, I remember my unsuccessful sketch and I think: Will I be a great artist?

Moreover, Chagall sees himself as being charged with a "mission." After many years of living in foreign lands, he desired "to be close to this land, to the biblical birthplace of the Jewish people, the land which is the reason and essence of our life and creativity. That which is found

on every page of the Bible is also found here, floating in the air, above the fields and in the hearts and souls of the inhabitants."

Chagall is then the greatest Jewish artist of our time, one whose Judaism anticipated his art and served him as a source of living inspiration for his creative imagination. The Jewish way of life, Jewish history, and the biblical heritage, as well as secular knowledge and powers of observation, nurtured his poetic soul. His entire œuvre, in all its richness and variations, is the fruit of these influences.

Was there anyone more worthy and able to decorate the Knesset's State Reception Hall?

Kadish Luz did not hesitate. He invited Chagall to decorate the large hall. Chagall also did not think twice. He came and created his works of art. And when his work was done, both men were happy and satisfied. They walked around with their heads in the clouds. In their eyes these were not simple decorations. They differ from the works with which Chagall decorated the cultural centers of other cities. An air of secrecy and the deepest mystery envelops these works, the summit of the poetry and mysticism that are found in Chagall's greatest works. Kadish Luz said: "Chagall's works make a deep impression on me. My heart opens as if to enfold them And Chagall says:

"I have visited this land many times and each meeting with it deepened in me my ties to it, so that I wished to leave here and there some sign of this bond. . . and now I and my creations have entered the Parliament of

Jerusalem, the Knesset: in its hall, on its walls and floor. . . . Thus I became close to the land and created my biblical imagery. I felt as though I had been born anew; no longer am I as I was. It is hard for me to explain how and why.

Chagall's words at the dedication ceremony for the Gobelins tapestries made a deep impression on us. The artist of the "texture" and "chemistry" of matter, of color, light and shade, landscapes, forms and images, is also an artist of the written and spoken word. His words and sayings merge with his artworks and add warmth and love to them.

ISRAEL YESHAYAHU
Speaker of the Knesset

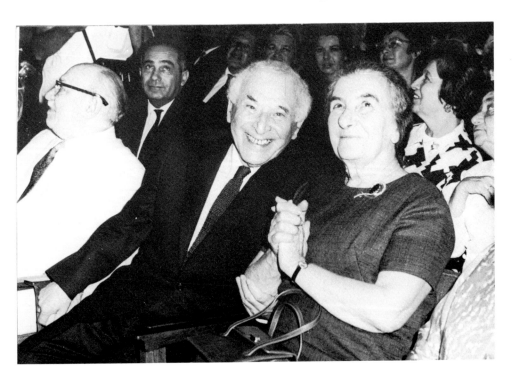

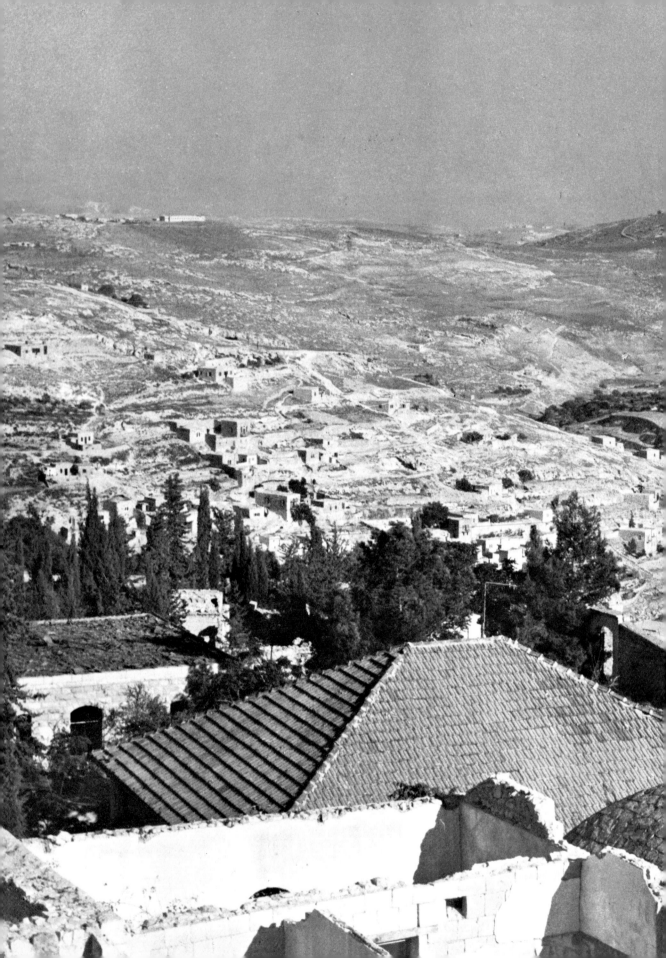

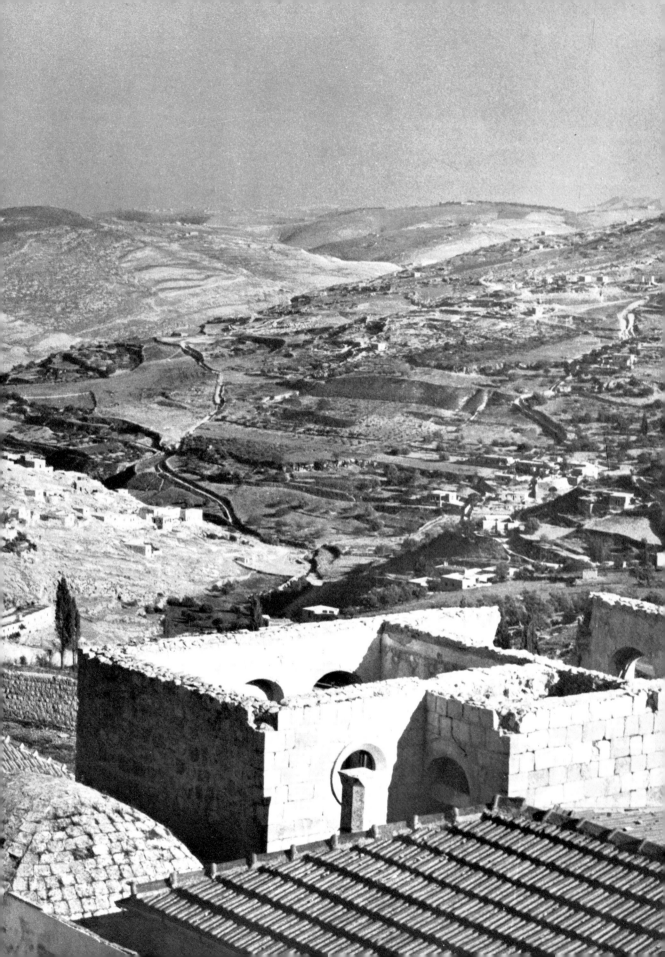

MARC CHAGALL
AND THE KNESSET

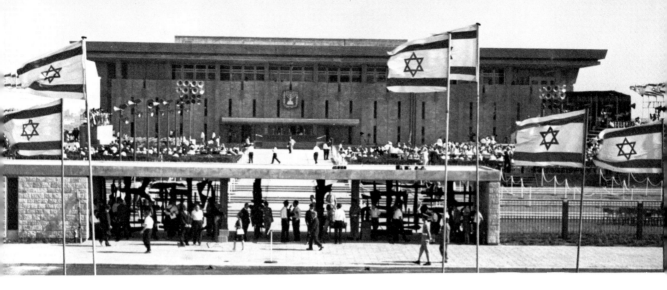

Photo, Israel Embassy, France.

THE KNESSET BUILDING IN JERUSALEM.

THE task of selecting artists to decorate Israel's Knesset could not be an easy one. The consensus of opinion held that the decorations of the building housing the first Parliament in the history of the Jewish nation should symbolize the many levels of Jewish existence from the dawn of history to the present day, with special emphasis on the Holocaust and the birth of the State of Israel. The artists should be Jewish, and, if possible, Israeli, and they must work in a style and idiom which could be easily understood by the people whose representatives composed the Knesset.

There were to be disagreements as to the choice of artists and the composition of the selecting committee, and at one point, a full debate raged over the possibility of including abstract art in the Knesset. On one subject, however, there could be no disagreement: a major part of the art works in the Knesset should be given to Marc Chagall and everything possible must be done to facilitate his participation. Chagall, the painter from Vitebsk who had adopted France as his second home, and who has always expressed in his work the essence of the Jewish soul. His etchings and lithographs illustrating the Bible had revealed his interest in the roots of Jewish history, and his magnificent stained glass windows of the twelve tribes at the Hadassah-Hebrew University Medical Center at Ein Kerem in Jerusalem bore ample witness to his ability to translate the Bible into clearly comprehensible images. Furthermore, he was not just an important artist in limited Jewish circles, but one of the pioneers of modern art, sought after in Europe and America, and any work he might do for the Knesset would be a prize well worth displaying. He was the obvious first choice of the late Speaker of the Knesset, Kadish Luz.

However, the story of Chagall's Knesset decorations was not by any means a one-sided pursuit. As much as the Knesset desired his participation in the decorations, so also did Chagall wish to contribute to them. He was extremely enthusiastic about this work, which became a labor of love and a gift from him to the Jewish people and Israel. Even more than in the

Hadassah windows, where he had been restricted to non-human symbols, could he express here the entire history of his people, the many strands of its existence, and its focal point—the Land of Israel and Jerusalem. Not content to decorate only one wall, he would add more and more to his generous gift. He began by supervising every detail of the hall in which his work would be placed, selecting the marble for the floor and columns, the ceiling blocks and even the type of glass to be used in the windows. Soon he had added a floor mosaic and then a wall mosaic, even sending his favorite mosaicists from Paris to Jerusalem to execute his designs.

Chagall's "romance" with the Knesset was a long one, stretching over a period of time. As the plans for the Knesset neared completion in the summer of 1960, Kadish Luz, who was at that time the Speaker of the Knesset, was introduced to Chagall, and an initial agreement was reached. The next few years were spent in discussion over the type of work Chagall would contribute and the part of the Knesset he would be called upon to decorate. During a trip Chagall made to Israel in 1962 for the inauguration of his Hadassah windows, the artist and Kadish Luz decided that the large reception gallery, the "State Room," would give Chagall the most scope for a large decoration. At first they considered stained-glass windows, and then a mural, but by mid-1963 Chagall had decided that tapestries would be the most appropriate type of decoration for the long, well-lit gallery wall. After discussing

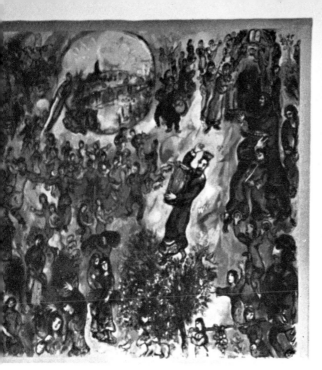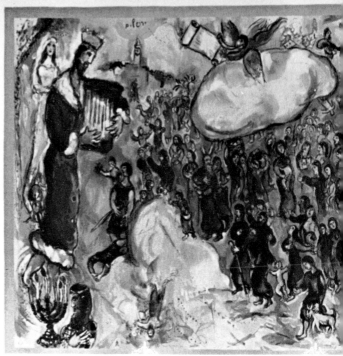

THE THREE TAPESTRIES. FROM LEFT TO RIGHT : "THE ENTRY

the possible subject matter with Kadish Luz; who suggested at first a history of the Jewish people from the return to Zion up to and including the creation of the State of Israel, Chagall set to work, finishing the first cartoon (the detailed painting from which the tapestry would be copied) before the end of the year. On November 30, 1963, this cartoon was given to the Manufacture Nationale des Gobelins, the famous tapestry manufacturers who had preserved the traditions and techniques which had made French high-warp tapestry sought after the world over for hundreds of years. After another visit to Israel, in December 1963, during which he discussed with Kadish Luz his wish

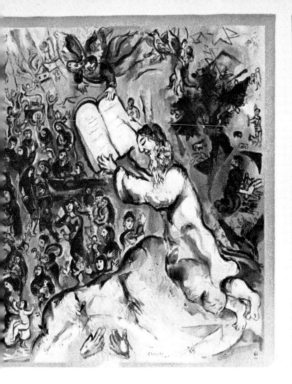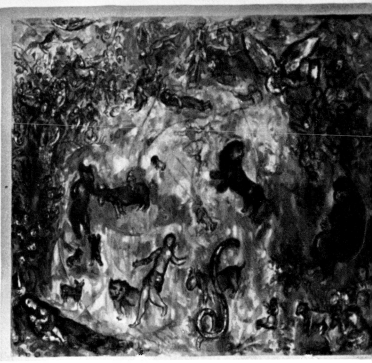

INTO JERUSALEM," "EXODUS" AND "ISAIAH'S PROPHECY."

to incorporate the important figures of Moses and David into the tapestries, Chagall completed the next two cartoons, and by the summer of 1964 he had handed them over to the Gobelins studios.

The Gobelins experts had meanwhile been extremely busy trying to find a way to translate Chagall's first cartoon into a tapestry, a task which posed seemingly insurmountable problems. First of all, there were the usual difficulties in transforming a work of art from one medium to another, each having its own special character and rules. Whereas the painting was built up of broad and fine brushstrokes in thin or thick layers of paint set one on top of the other, the tapestry would consist of

minute stitches set side by side. The resulting work must, however, convey the feeling of Chagall's free brush-strokes without abandoning the special characteristics of thread and material that are fundamental to tapestry. Chagall's color itself posed problems: it is so rich, so full of delicately nuanced tones, that an infinite number of colored threads would be needed to copy it and the end-product would be incompatible with the classical Gobelins style, which called for a more limited range of color. This type of copy would also be impractical as such a tapestry could be completed only in ten years time. Chagall finally reached a compromise with Maurice Cauchy, head of the Gobelins studios, which satisfied all sides and allowed the tapestries to be finished within four years. A color palette was established of 160 tones of thread, and these were used to translate Chagall's colors into material. This was not as great a sacrifice as it may sound at first, as the myriad of minute stitches which compose the tapestry also play one against another, creating rich optical mixtures in the spectator's eyes when viewed even from a slight distance.

Another problem concerned the size of the painted cartoons as opposed to that of the projected tapestries. Each of Chagall's cartoons was slightly over four feet high and would have to be enlarged almost four times to attain the required 15′ 8″ of the completed tapestry. Extreme care had to be taken in enlarging the cartoons so that there would be no loss in color value and harmonic balance between the tones. In order to make sure that all these problems were solved before work

on the actual tapestries was begun, two trial pieces were selected from the "Peace" cartoon: the figure of the prophet and part of the background with its subtly shaded tones.

During this trial period and the subsequent weaving of the tapestries, Chagall was a frequent visitor to the studios, discussing with the master-weavers the solutions they had found, the simplifications they had made and the dramatic effects of contrast they had created which he had not originally intended, but soon agreed to include. The resulting tapestries, actually begun in February 1965 and finished in early 1968, are a joint work of the artist and the master-weaver and bear the signatures and dates of completion of both masters. Thus the earliest tapestry, "Peace," is dated 1963 by Chagall and is signed in the margin "E. Melot 1967"; "Exodus," dated 1964, is also signed "Bourbonneaux 1968"; and the "Entry into Jerusalem," of 1964, carries the inscription "E. Lelong 1968." In each case, the master-weaver's inscription appears beside the Gobelins trademark. The results of this teamwork were so satisfactory that the Gobelins studio asked and was granted the right to copy one of the tapestries for its own tapestry museum.

In the meantime, in July 1964, Chagall, while finishing his last cartoon, had gone over the plans for "his" hall in detail with the building supervisors and had decided to incorporate mosaic segments into the marble floor. These mosaics, divided into twelve parts, were to form a transition between the tapestries

and the warm brown and beige marble he had selected to cover the floors and columns. The problems of translating Chagall's work into mosaic were even more complicated than those of transforming it into tapestry. Whereas, theoretically, there are an unlimited number of colors of dyed yarn from which the artist could choose, a floor mosaic, in order to stand up to the wear and tear of people walking on it, would have to be made of stone fragments, and its colors would be limited by the colors of the stones available. The colors chosen were warm earth tones—beiges, browns, deep oranges, and warm grays—colors which would harmonize with the marble of the floors and the beautiful Eilat stone, ranging from turquoise blue to green. Even granting a variation in tone between one stone and another, and within the individual stone segments themselves, such a limitation would impose strict restrictions on the artist who enjoyed delicate nuances of color so greatly.

Chagall's sketches here were not as complete as were the tapestry cartoons. They consist of full-size mosaic cartoon drawings, without color indications, and both the colors and the problem of translating Chagall's extremely sketchy lines into mosaic were decided on between the artist and the mosaicists orally and thereafter were left to their discretion. For this reason Chagall insisted on entrusting the mosaics to his own experts, Mr. and Mrs. Lino Melano and their assistants, with whom he had worked on his mosaics for the Maeght Foundation in southern France, as they would

know exactly what he wanted almost without the necessity of explaining it to them.

During a trip to Israel in December 1965 to get the floor mosaics under way, Chagall decided to add still another mosaic, also to be executed by the Melanos, on the wall near the windows. It would be lit by the strong Jerusalem sun and would link the artworks within the gallery to the magnificent Jerusalem hills outside. The colors here would echo those of the floor, but the main accent would be on the dreamy blue and green Eilat stones. This mosaic would complete the hall, in which tapestries, mosaics, and the Jerusalem landscape engulf the observer in a special ambiance of their own.

The Melanos worked throughout the first half of 1966 and had the hall ready for the opening of the Knesset in August 1966. At that time the tapestries had not yet been completed, and photographs of them in the process of being woven were set up on the wall they would eventually occupy. The tapestries themselves were installed at a gala ceremony on June 18, 1969, and with them the decoration of the State Room, since called the Chagall Room, was completed.

In planning the Knesset art works, Chagall set himself many problems, not only on the technical level but on that of content as well. Taking into account Kadish Luz's wish for a history of the Jewish people, as well as the importance of the location of the decorations in Israel's Knesset in Jerusalem, he realized that his works had to reflect not only historical but spiritual

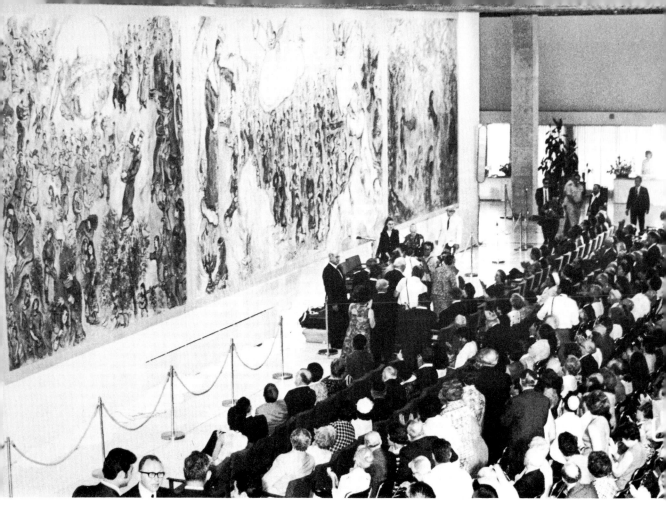

THE TAPESTRIES HANGING IN PLACE IN THE STATE RECEPTION HALL.

values. At the same time, it must be understood by the countless people who would daily visit the Knesset. The artist who is often thought to paint irrational dreams which are completely incomprehensible to the layman turned to the one source which would be clear to everyone—the Bible. Reworking his biblical drawings, he chose a few main scenes, and to these he added other episodes from the Bible as well as many nonbiblical figures. Together they would contribute to a multilevel message having a religious, historical, and national significance and even including a vision

of the future. He used symbols which would be familiar and readable to everyone, as he had attempted to do in the paintings that compose his *Biblical Message,* which he donated to France in 1967 in order to enable a museum to be established in Nice. Now, instead of just selecting the highlights of biblical history in chronological order, he drew his inspiration from the site for which his works were destined—the house of the governing body of the new State of Israel in Jerusalem—and created a message both for his people and about them which surmounts time and place.

THE OLD CITY AND THE TEMPLE MOUNT VIEWED FROM THE MOUNT OF OLIVES. *(Altas Photo).*

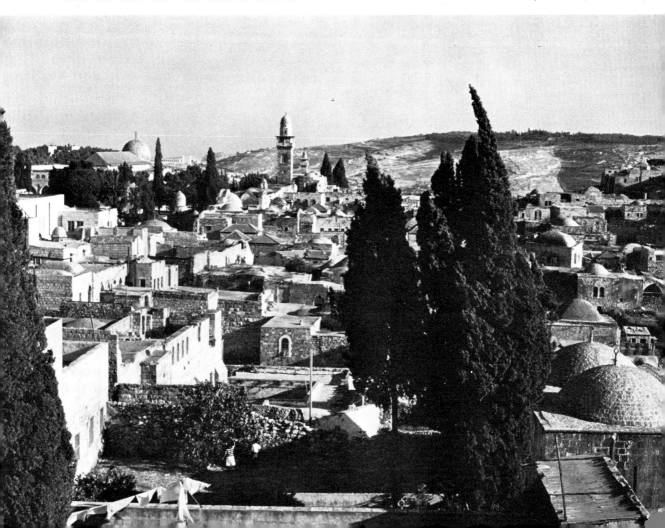

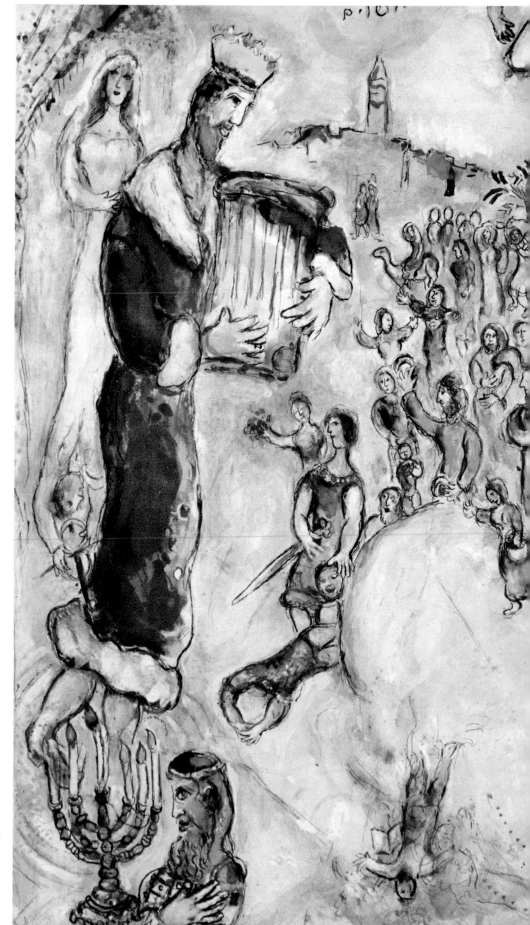

"EXODUS."
CARTOON.
GOUACHE.
2' 9 1/2" × 5' 5 3/4".
1964.

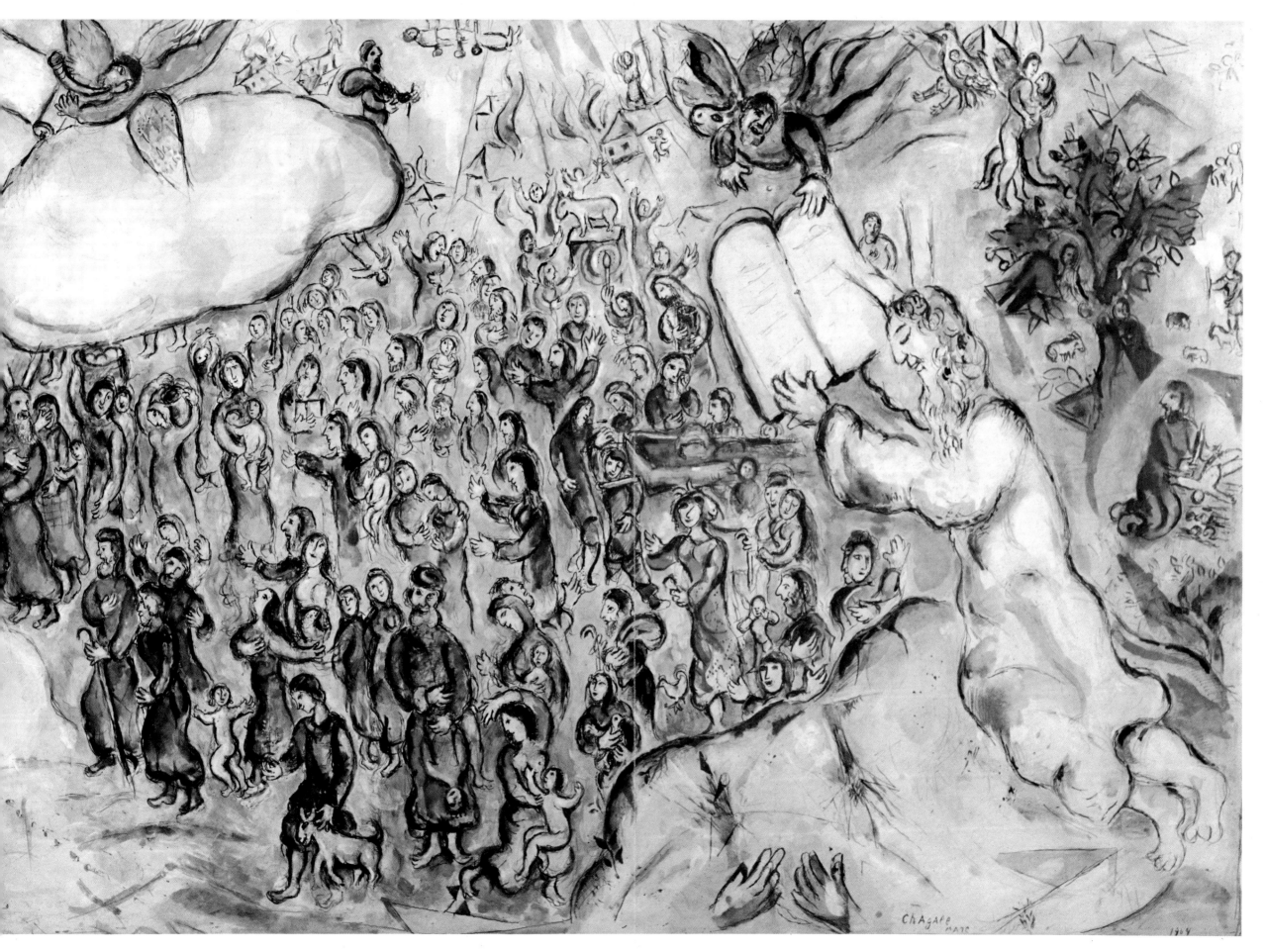

THE "EXODUS" TAPESTRY

THE central tapestry, the largest of the group, begins Chagall's multilevel narrative. Three major scenes here combine with several minor ones to enrich the artist's meaning. The center of this panel deals with the "Exodus"; Moses, in blue, leads the Children of Israel out of Egypt. Chagall follows the biblical text and the midrashic interpretations closely. The Israelites, of all ages and sizes, carry their few possessions, baskets of unleavened bread, and their household pets. Despite their haste they have found time to follow the instructions of their ancestor Joseph and to take with them the coffin containing his bones, the box being carried at the end of the procession (Exodus 13:19). They are protected by a large cloud from the Egyptians who pursue them, whose legs, visible under the cloud, indicate their presence on the other side. This cloud is the biblical "pillar of cloud" which led the Israelites by day and which, before the crossing of the Red Sea, protected them by dividing their camp from that of the Egyptians (Exodus 14:19 — 20). Chagall suggests the cloud's divine quality by setting an angel blowing a shofar above it, clearly the angel of the Lord sent to guide the Israelites on their journey (Exodus 23:20). The angel receives an open Torah scroll from a hand in the sky, repeating the theme of the giving of the Ten Commandments depicted on the right, but with a broader meaning—"*Matan Torah*"—the giving of the

Torah as a whole. The attainment of this body of traditions and laws, one of the main achievements of the Exodus, was to determine the future history of the Jewish people.

If we look for a time at this Exodus scene, and especially if we compare it to Chagall's other illustrations of this theme, we will detect its unique nature. First of all, whereas Moses is still well in the vanguard, he is no longer the only leader of the group. He and most of those who left Egypt with him did not live to cross into Israel, and indeed he yields precedence here to a small child, who alone crosses the large white barrier which separates this section from the symbols of Jerusalem on the left. Even more important are the two groups who have joined the Exodus. On the left, from around the side of the cloud, comes a group of people whose meaning is indicated by their camel and the palmlike tree in the background: they form an Exodus from the East, a symbol of the *aliya* of the Jews from Oriental countries to Israel. On the other side of the cloud, still another Exodus is depicted. Above a background of burning *shtetl* houses, a world turned topsy-turvy by the Holocaust, a dead body is set surrounded by candles, a perpetual reminder of the six million who died in Europe. From here the eternal wandering Jew, pack on his back, sets out to join those fleeing from the burning houses to mingle with the Exodus. Whether clutching a red Torah, or rasing a candle, these refugees do not dance around the golden calf who has strayed into their midst from the major

scene on the right, but seem to run horrified from it as well as from their burning village. This is the Exodus with which Chagall has been preoccupied since 1938, that of European Jewry, which he had joined himself when he fled to the United States after the Germans invaded France. These two modern-day Exoduses—that of Eastern and that of European Jewry—join in the biblical Exodus from Egypt. This combination and identification of the present with the historical past raises the whole to the level of a symbolic eternal Exodus, a constant return to the Promised Land.

The "Exodus" moves between the two great leaders of Israel: Moses and King David. On the right, Moses receives the Ten Commandments. Rays of light issuing from his head, as in all Chagall's representations of him, he kneels, eyes lowered, to receive the Tablets of the Law from God. As with all the themes in the tapestries, this scene is based on Chagall's Bible illustrations as he had developed and enlarged on them in paintings and stained-glass windows after he first began work on them in the 1930's. This particular scene was depicted in a large painting, part of Chagall's *Biblical Message,* and in a window for the Cathedral of Metz, and these works do much to explain the incorporation of certain elements into the tapestry. For instance, both the golden calf at the left, and Aaron, the High Priest, set near the Menorah at the far left, had been included in this scene in these earlier works.

KING DAVID PLAYING HIS LYRE. EXODUS CARTOON (DETAIL). GOUACHE. 1964.

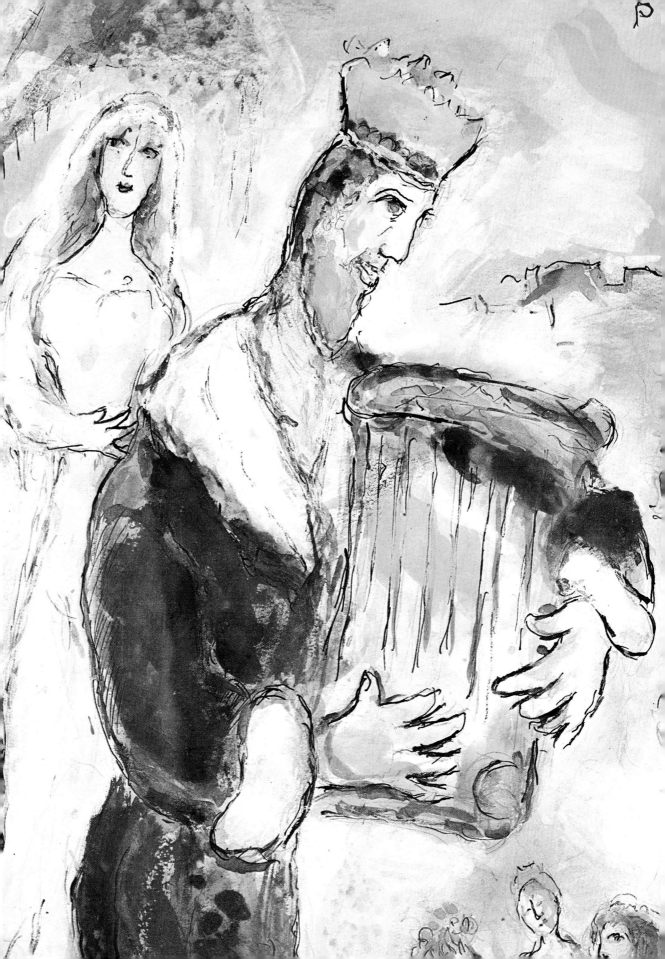

There is, however, one point on which this section is different from all of Chagall's former depictions of the scene. He had always previously followed the text closely by portraying the descent of God's spirit on Mount Sinai in the form of a cloud, out of which the hand of God is extended to give Moses the Tablets of the Law (Exodus 24:15 — 16). Now, for Jerusalem, he worked out a new interpretation of the text, which he repeated in his *Exodus* lithographs of 1964 — 1965, on which he worked simultaneously with the tapestries. He still adheres to the biblical story, but illustrates different parts of it. Thus, near the Ten Commandments appears a small figure who views the miracle from afar. This is Joshua, who alone went up on Mount Sinai with Moses to await God's orders (Exodus 24:13). In a like manner we can explain the figures seemingly being carried by a bird above as symbolizing God's words to Moses on his arrival at Mount Sinai: "Ye have seen what I did unto the Egyptians, and how *I brought you on eagles' wings* unto Myself" (Exodus 19:4).

The major change, however, is the depiction of God Himself giving Moses the Tablets. This is textually correct, for although the Israelites saw God's spirit descend on the mountain from afar, Moses actually went up alone into the cloud to communicate with God face to face. Chagall's problem was how to portray God. He showed Him as a venerable bearded man, as the European pictorial tradition demanded and in the spirit of the early midrash, which held that whereas on the Red Sea God had manifested himself to the

Israelites as a warrior, on Mount Sinai he appeared to them in the guise of a compassionate old man. He added two details which can be explained by the biblical texts on which he drew. God has several flamelike wings, for His appearance seemed to the frightened Israelites "like a devouring fire on top of the mount" (Exodus 24:17 – 18). He is accompanied by an angelic winged bull, one of the cherubim, who, following Ezekial's descriptions (Ezekial 1:10 and 10:14, 20 – 22), has been linked to an ox or bull. The presence of the winged cherub is also explained by texts, although not those in Exodus. God is often said to sit, ride or fly away on a cherub (Psalms 99:1 and 18:11) or to rise up from behind one (Ezekial 9:3). This imagery was taken from the idea that God's spirit rested on the Ark of the Covenant, which was crowned by two golden cherubim. For instance, after the dedication of the Tabernacle which housed the Ark, God spoke to Moses from between the two cherubim (Numbers 27:18 – 22). Thus, when Chagall wished to give a unique depiction of God, the image of the Lord not riding on, but escorted by a winged cherub immediately suggested itself and was adopted.

But why did Chagall choose to depict God specifically in the Jerusalem tapestries? The inspiration for the change was apparently the conversations between the artist and Kadish Luz on the uniqueness of Moses, the only mortal "whom the Lord knew face to face" (Deuteronomy 34:10). These conversations were summarized in a series of biblical quotations that Luz

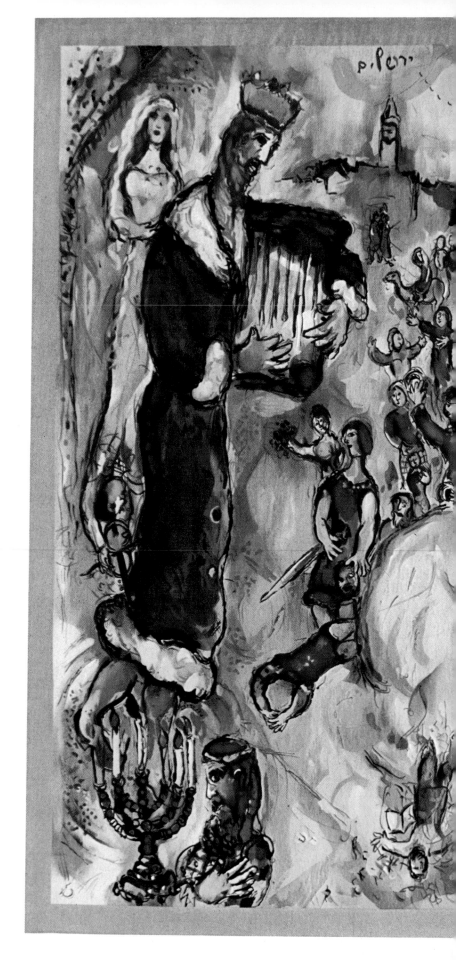

"EXODUS" TAPESTRY.
EXECUTED AT THE
GOBELINS WORKS, PARIS,
BY Mme BOURBONNEAUX
AND ASSISTANTS.
15' 7" × 29' 8". 1964.

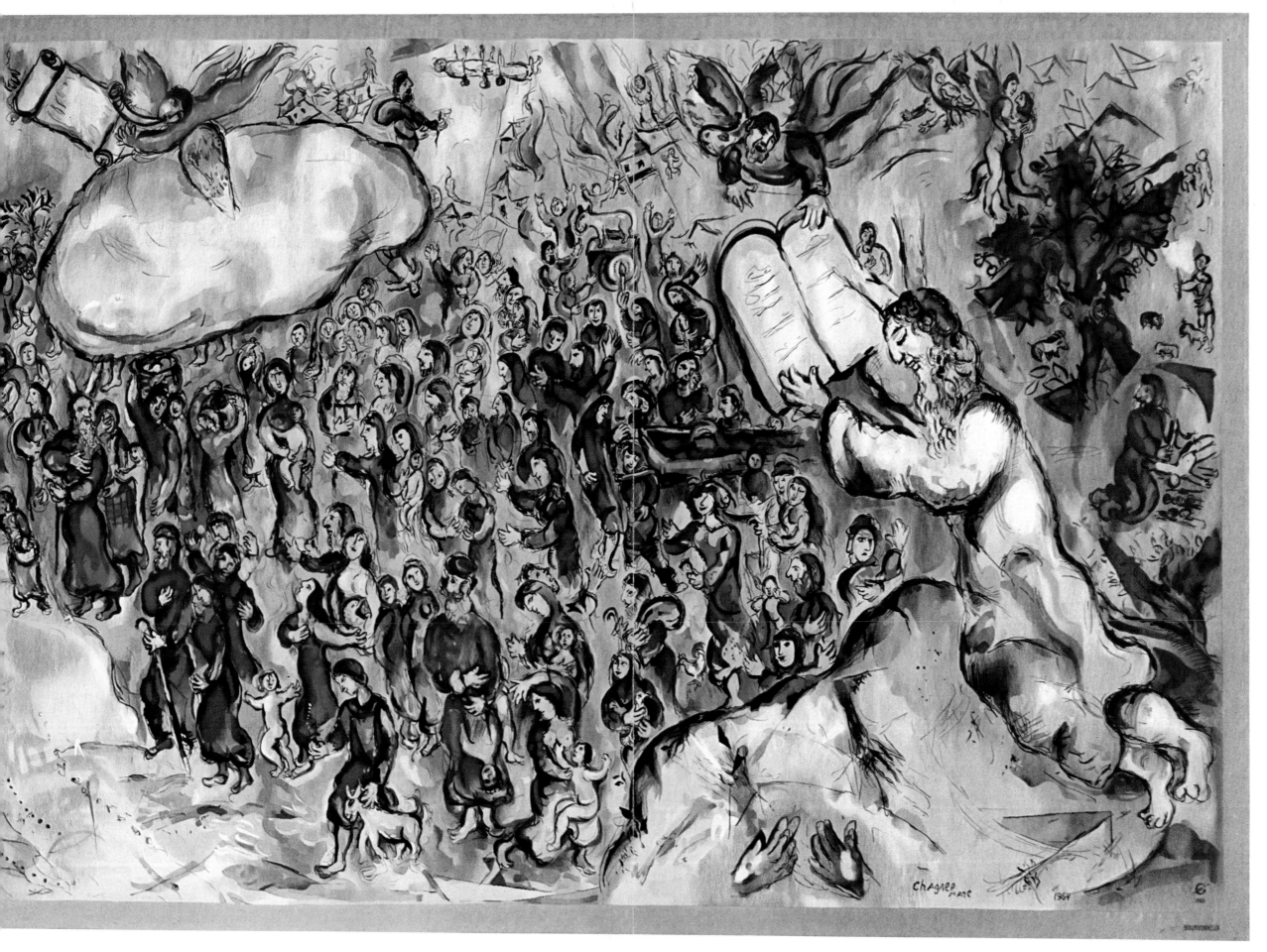

gave Chagall in December 1963 just before he designed this tapestry, in which Moses' personal contact with God is stressed. Yet Chagall knew that anyone who looks on God must die, and he lowered Moses' eyes: he does not look toward the gift he receives from on high. The appearance of God in Jerusalem may also have struck the artist as especially appropriate, as it is the city in which the sages held that He chose to dwell. Thus despite any forebodings over ultra-orthodox reactions to such a depiction, Chagall dared to add it to his tapestry, for if God cannot be revealed to His children in Jerusalem in giving them His laws, where can He be revealed?

The acceptance of the Torah by Israel is symbolized by the two hands which reach up from the spectator's space at the foot of the Mount (and of the tapestry). These hands, which are not posed as in the traditional priestly blessing, seem to be extended toward the Ten Commandments, as though to receive them from Moses directly before he has a chance to break them. In this context, we must note that the golden calf, always stressed by Chagall in similar scenes by means of a jubilant crowd being drawn away from the Mount to worship the idol, is here so vestigial that it has been completely absorbed into the scene of the Holocaust on the right and is not clearly connected to Moses at all. One could almost infer that this time there will be no disruption, and the Covenant will pass from God through Moses straight to the willing spectator who will say, "All that the Lord hath spoken will we do and obey" (Exodus 24:7).

To this dominant scene of God's covenant with Israel, Chagall added three more. Above Moses, at the top of the tapestry, Jacob wrestles with the Angel, refusing to release him until he receives his blessing. The parallel between this scene and that of Moses receiving the Tablets from God are twofold. First, it was a meeting of which Jacob said: "I have seen God face to face, and my life is preserved" (Genesis 32:32), which resembles Moses' relationship with God. Secondly, after he had wrestled with the Angel, the latter changed Jacob's name to Israel, "for thou hast striven with God and with men, and hast prevailed" (Genesis 32:29). This name was shortly afterward conferred on Jacob by God Himself, who promised him that his descendants would be a great nation to whom the Lord would give the land already promised to his father, Isaac, and his grandfather, Abraham (Genesis 53 : 10 — 12). His descendants, *B'nei Israel,* the children of Israel, here attain a name and a national identity, which would in time give them the name of the State of Israel.

Below Jacob a strange tree swarms with angelic forms. Beside it a shepherd stands startled, his flock grazing around him. The scene suggests Moses' first meeting with God, who called to him from within a burning bush, while Moses was herding his father-in-law's sheep at the foot of "the mountain of God" (Exodus 111:1 — 7). This passage another of those suggested to Chagall by Kadish Luz, goes on to descibe God's command to Moses to return to Egypt and free the children of Israel, bringing them back to God's

mountain to worship him there. The pictorial combination of this minor scene with the nearby major scene locates the tree very close to the spot on which Moses receives the Commandments.

But this tree has another meaning as well, as it also functions in the Sacrifice of Isaac pictured below. Here, Abraham kneels ready to sacrifice his beloved son, Isaac. Suddenly he is stopped by the voice of an angel hidden in the tree who instructs him to substitute the ram caught in the bushes (here shown under the tree) for his son, as God was merely testing his willingness to sacrifice without question the thing dearest to him. Because of his unhesitating submission to God, Abraham received the blessing that his descendants should be many as the stars of Heaven and that through them all the nations of the world would be blessed (Genesis 22:17 − 18).

Here again Chagall made a rather interesting change in his usual depiction of the scene. Recently, the artist, who had developed an indentification between Christ and the martyred Jew during World War II, had been equating Christ and Isaac, portraying Christ bearing the cross as a background for the Sacrifice of Isaac, both in his *Biblical Message* painting and in his window for the Cathedral of Metz. This combination was an acceptable one within a Christian context, in which Isaac was a prefiguration of Christ and the Sacrifice a prophecy of the Crucifixion. It was not a combination which would have been acceptable in the Knesset, and Chagall was counseled against it. But the artist's per-

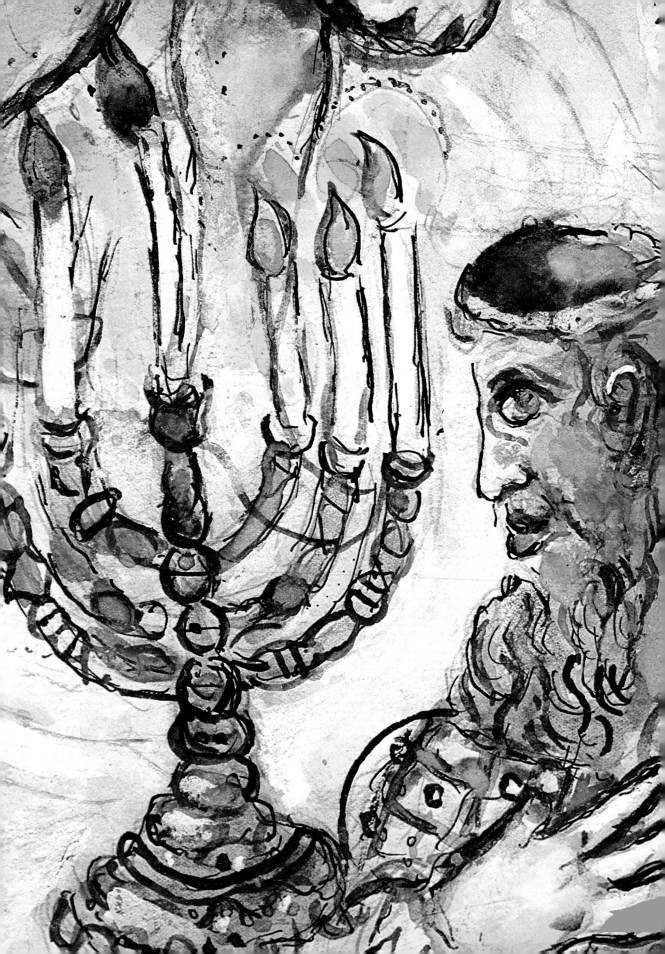

sonal belief in Christ as the perfect symbol of the suffering Jew could not easily be silenced, and instead of abandoning it, he slipped it in, in an "irreproachable" manner: Christ does not appear, but Isaac is placed on the altar with his arms spread wide in the shape of a cross. The pose is not stressed but is meaningful to those familiar with Chagall's usual symbolism and is quite different from Isaac's previous position in similar scenes.

Chagall's meaning here remains, however, distinctly Jewish. Abraham, for the first time in the artist's work, turns his back on his cruciform son, gazing neither toward the angel, barely distinguishable amidst the foliage of the tree, nor toward the ram. His attention is caught instead by Moses receiving the Tablets of the Law, as though he too participates in this event and reaffirms his acceptance of the Law and of Judaism.

This side of the tapestry thus represents God's covenants with Israel and the spiritual values on which Judaism is founded. With this "backing," the multi-level Exodus moves toward the left to encounter King David and his city, Jerusalem, clearly labeled in Hebrew above a depiction of the walls of the old city and the Tower of David.

To reach this brilliantly colored area of the tapestry, the Hebrews must surmount a cloudy rocklike barrier, led by a child. The first person they encounter is the youthful David holding the head and sword of the slain Goliath in his hands while standing over the headless body. Chagall added a figure rejoicing over David's

AARON AND THE MENORAH. DETAIL OF THE "EXODUS" CARTOON GOUACHE.

victory in the background and singing: "Saul hath slain his thousands, and David his tens of thousands" (I Samuel 18:7). David the warrior is set at the entrance to the Jerusalem part of the tapestry as a reminder of the difficulties the Jews had always encountered in entering their land, the wars they had constantly to fight, which had come to a temporary end during David's lifetime. These wars left countless dead, both Jews and their enemies, and one of these sprawls below upside-down beside his book in a pose recalling both that of Goliath and of Isaac. But Israel had always eventually won the right to the Promised Land, not through mere physical might but, as in the case of David who came armed with only his sling to face Goliath, convinced that he would win as he was spiritually armed "in the name of the Lord of hosts, the Gods of the armies of Israel" (I Samuel 17:45).

After overcoming all obstacles, the children of Israël are met by David in his other guise. Crowned and wearing a regal red robe, David the King, the conqueror of Jerusalem who made it into the capital of Israel, stands above another symbol of the Holy City. In the lower left-hand corner, Aaron, forefather of the High Priests, wearing his priestly breastplate of twelve semiprecious stones, stands beside the menorah. This group, which Chagall usually sets beside Moses receiving the Ten Commandments, has been moved over to the Jerusalem part of the tapestry to symbolize the Temple in Jerusalem which housed the menorah and was served by the High Priest. These two rulers of Israel,

AROUND THE GOLDEN CALF. DETAIL OF THE "EXODUS" CARTOON. GOUACHE. 1964

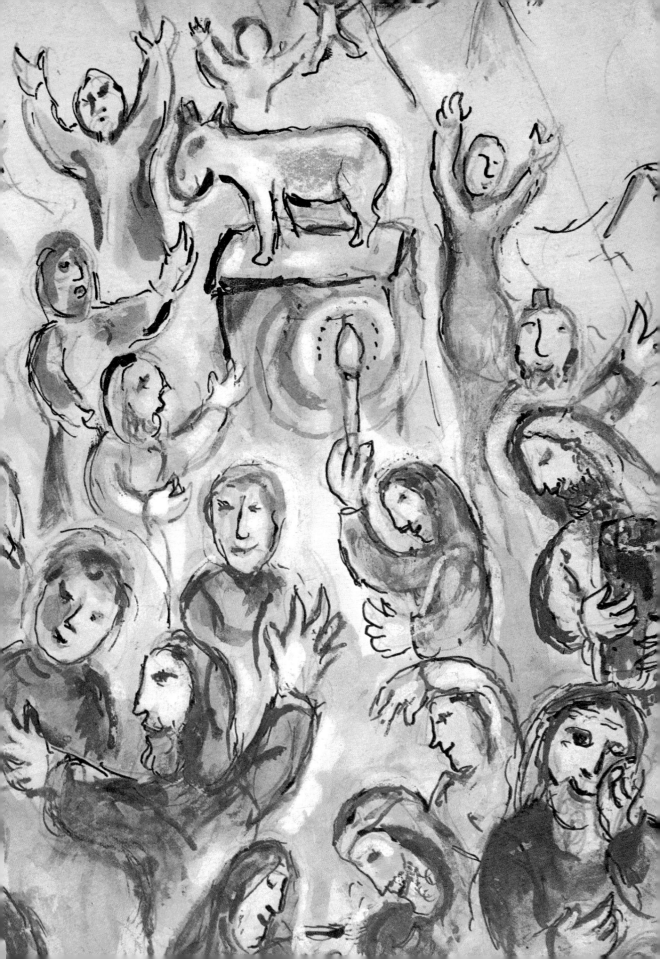

the secular King and the religious High Priest, each checking and balancing the other, formed a stable working government during the height of Israel's power. But even the secular ruler has a strong spiritual side, for David is not merely the King, but also the Psalmist, playing his lyre as he composes his songs to God.

Behind the King appears a bride coming forth from behind a curtain, with the bridal canopy hinted at lightly around her head. She is joined below to a fiddler who celebrates her approaching nuptials, and she becomes an image of Jeremiah's prophecy of the return to Zion: "Yet again there shall be heard . . . in the streets of Jerusalem . . . the voice of joy, and the voice of gladness, the voice of the bridegroom and the voice of the bride . . . for I will cause the captivity of the land to return as at the first, saith the Lord" (Jeremiah 33 : 10 — 11). Jeremiah himself connects the bride to the Davidian dynasty and to the Temple priests by continuing:

In those days, and at that time will I cause a shoot of righteousness to grow up unto David; and he shall execute justice in the land. . . . For thus saith the Lord: there shall not be lacking from David a man to sit upon the throne of the house of Israel; neither shall there be lacking from the priests the Levites a man before me to offer burnt offerings. . . . As the host of heaven cannot be numbered . . . so will I multiply the seed of David My servant, and the Levites that minister unto me. Jeremiah 33 : 15 — 18,22]

The bride has another level of meaning as well. Not David, but his son Solomon had written of the Shulamite in this Song of Songs as "my sister the Bride" and had sung of this great love for her. But the Song of Songs is not a simple love song. It has been interpreted as a mystic allegory of the love between Israel and God, and the bride is a symbol of the "Virgin" of Israel, *Betullat Israel* who joyously celebrates her spiritual union with God.

The journey of the Exodus ends then in the entry into Jerusalem, the site of the Temple and the capital of the Kings of Judea, where a spiritual unification between the people and their God can be achieved. This is the simplest part of the tapestry, and Chagall left it so intentionally, as he had already planned to develop this theme in a tapestry of its own which would stress the many different levels of entries into Jerusalem as a fuller development of the multilevel and multitemporal Exodus.

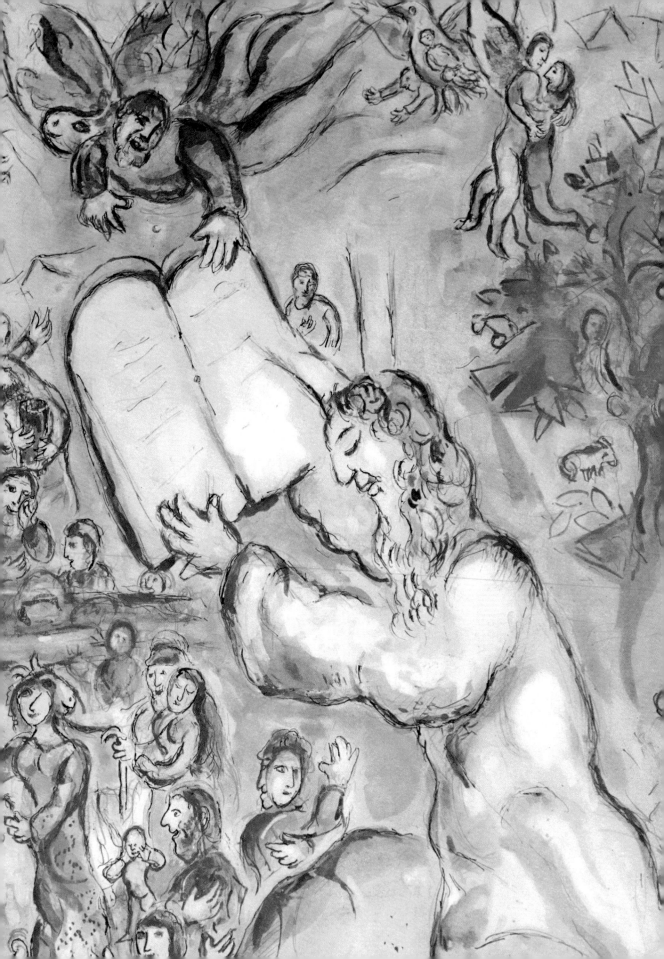

MOSES RECEIVING THE TEN COMMANDMENTS.
DETAIL OF THE "EXODUS" CARTOON. GOUACHE. 1964.

THE "ENTRY INTO JERUSALEM" TAPESTRY

THE left-hand tapestry, the "Entry into Jerusalem," is a continuation of the left side of the "Exodus" panel not only thematically but visually. The motion of the "Exodus" carries the eye from the white robed Moses on the right toward King David, whose brilliant red robe is the strongest single note of color in the entire composition. A very similar figure of King David, dressed in the same bright red gown and still carrying his lyre, appears at the right of the "Entry into Jerusalem." By repeating this figure, the artist leads our eye from one King to the next, from one tapestry to the next. King David's entry into Jerusalem here becomes the logical outcome and continuation of the Exodus. In fact, it almost seems that after welcoming the Israelites to Jerusalem, he turned to lead the procession further into the heart of the city.

The actual scene depicted is taken from the second book of Samuel, chapter 6. There we are told that soon after David conquered Jerusalem and established it as his capital, he had the Ark of the Covenant brought to the city, and he and all the people accompanied the ark, playing on all manner of instruments. David leads the procession composed of men blowing shofars and horns in blue and girls dancing and playing on cymbals or tambourines.

KING DAVID ENTERING JERUSALEM. DETAIL OF THE "ENTRY INTO JERUSALEM" CARTOON. GOUACHE. 1964.

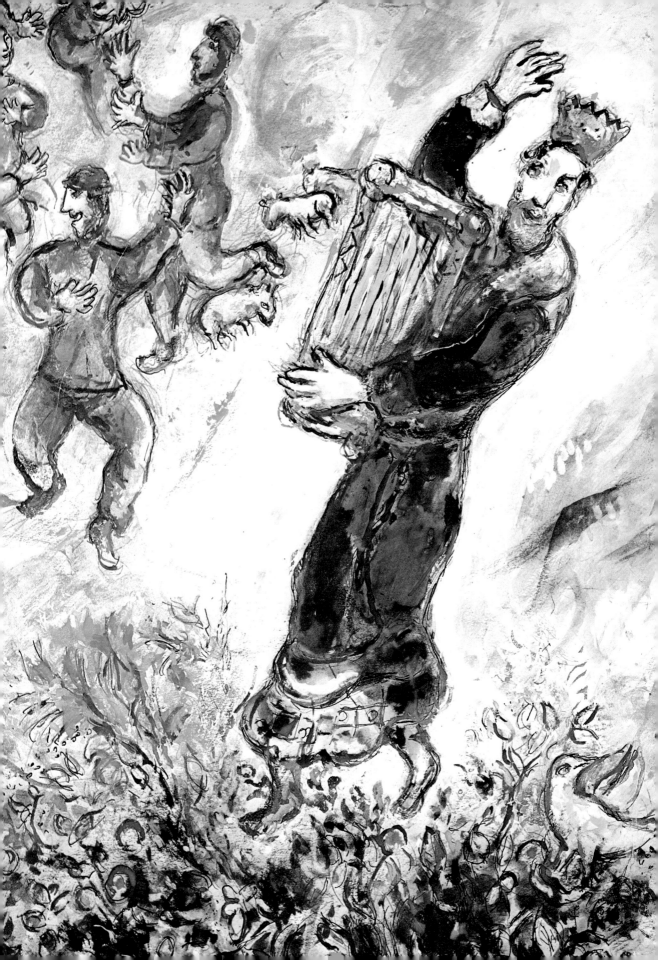

Behind them comes the Ark of the Covenant, which Chagall as always portrays as a traditional European Ark with its Ark-cloth decorated with the crowned heraldic lions of Judah holding a Torah crown and set under the Tablets of the Law. Chagall chose in this case not to follow the biblical description of the Ark, a gold-plated wooden box surmounted by a gold cover on which rested two winged cherubim (Exodus 25:10 — 22). This decision dates back to Chagall's original Bible illustrations of the 1930's, for which, in a search fot authenticity and truth, he had first visited Palestine. This first trip had included not only a general tour of biblical sites, but visits to the major synagogues of the Holy Land, for instance those of Safed. He had painted the synagogue interiors there, including their Arks, a subject which had not interested him previously. They made such a deep impression on him that when he began work on his biblical illustrations after returning to Paris, memories of the synagogues merged with those of the Bible and of the Holy Land to produce an Ark of the Covenant that was anachronistic in strict historical terms but true to Chagall's understanding of the continuation of Jewish traditions from the past to the present. In the tapestry he adds another anachronism by having fiddlers and drummers accompany the Ark instead of players on instruments such as the psalteries, sistras, and timbrels mentioned in the biblical text. This change was not effected merely because no one is sure as to the shape of these instruments, but rather because Chagall wished to stress that his representation of David's entry is

manifestly symbolic, not strictly historical. This mixture of modern and biblical motifs is a technique we have already encountered in the "Exodus" and will meet over and over again in the present tapestry.

The broader sense in which the "Entry into Jerusalem" must be understood is immediately apparent if we follow its line of movement. David leads his procession directly into another group of rejoicing people, among whom we can make out Chassidim, in knee-length kaftans, and Chalutzim, the men in Russian blouses and "tembel" hats and the women in dresses. They all join together in a dance that is a combination of a Chassidic dance and a hora, accompanied by the ever-popular fiddlers and cymbal or tambourine players. They form the modern counterpart to David and his musicians and seem to join in his celebration and enter Jerusalem with him, their movement continuing that of the King and leading our eye still further toward the left.

Following their rhythmic dance, we are led to a group of symbols that pertain to the founding of the State of Israel. Directly above the fiddler on the left stands a strange two-faced man in green who holds a bow, a biblical weapon, despite his modern dress. One of his faces is young and looks behind him warily toward a goat-headed man. The other face, more mature, bearded, and displaying phylacteries on its brow, turns forward, his eyes half shut in introspection. These two heads symbolize the dual character of the early pioneers who built the State, their deep religious

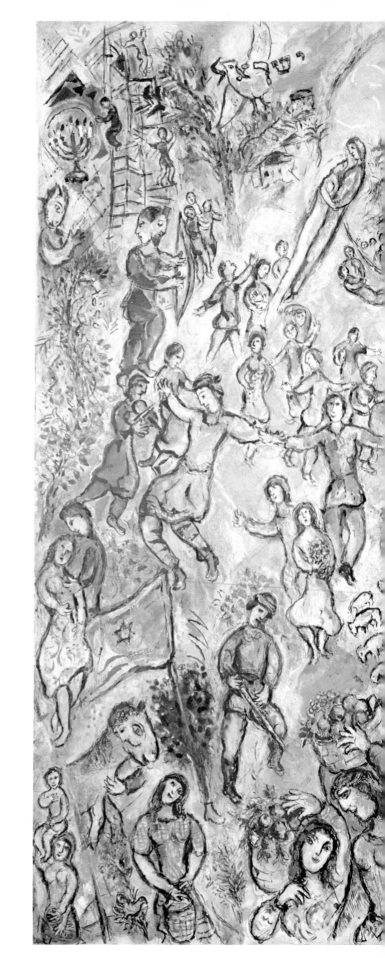

"ENTRY INTO JERUSALEM."
CARTOON. GOUACHE.
4' 2" × 4' 9". 1964.

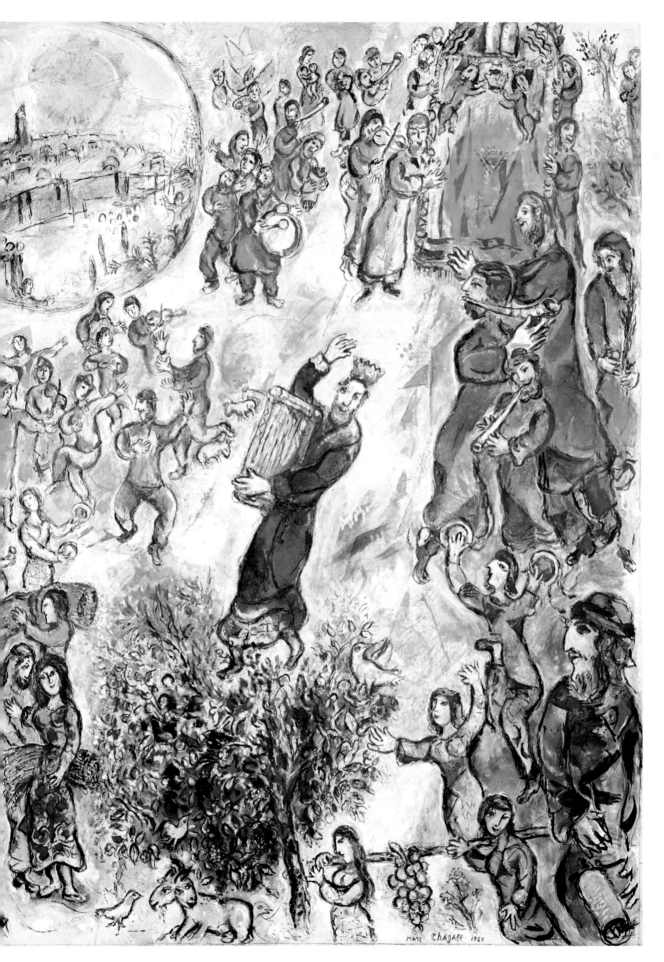

Marc Chagall 1964

beliefs and retention of tradition and their wary, youthful, and warrior-like behavior. This is the same type of combination that was found in the group of dancers in the center, as well as in the several facets of King David that were represented on the left-hand side of the "Exodus."

Above the warrior, whose two heads guard him on all sides, a watchtower from the days of the early stockade settlements (called, in Hebrew, "a wall and a tower") guards the small red-roofed houses of a kibbutz. Over it, the bird labeled "Israel" flies toward the tower and the menorah beyond it. The menorah, the official symbol of the State of Israel is being lit by one of the children who climb gaily and fearlessly on the tower. These symbols of the State are continued on the lower left, where, under the dancers, Chagall has painted another pioneer soldier, this time bearing a rifle and dressed like a Russian peasant. According to the artist, this figure represents the second *aliya,* the second wave of immigration to Palestine from Russia and Eastern Europe at the beginning of this century, which contributed so greatly to the founding of the State. Beside him, another pioneer, barely distinguishable amidst the foliage, carries the Israeli flag which almost seems to have merged with the bush and the pioneer's shoe and to be marching forward on its own. Surrounding these symbols are pastoral scenes: lovers with flowers and sheep, a mother carrying her child on her shoulder, a farmer stroking and blending into his horse, and farm girls bearing baskets of fruit and flowers

and sheaves of wheat. This pastoral quality carries over into other areas of the tapestry as well. For instance, between King David and the dancers, a modern shepherd leaves his flock to join in the celebration of the modern entry into Jerusalem.

In the lower right-hand corner, Chagall returned to the Bible to reinforce the connection between David's entry into Jerusalem and the Exodus. Here he represented two figures based on the spies who returned to Moses from the Promised Land with an enormous bunch of grapes to symbolize the extreme fruitfulness of the land they had surveyed (Numbers 13:23). This group, which seems to have wandered in from the central tapestry, is connected visually with David's entry by means of the two similarly dressed and colored dancing girls, who are actually an extension of the musicians surrounding David and the Ark. The grape-bearers are also linked to the symbols of the fruitfulness of the new State on the left, and this connection is stressed in the finished work, although not in the sketch, by transforming the male spies into women similar to the girls carrying fruit at the left.

If we compare Chagall's cartoon at this point to the early pencil sketch, we will find that almost all of these elements were already suggested in it. However, at some point between the drawing and the completion of the cartoon, Chagall became caught up in a series of mental associations that caused him to enrich his work with several new figures who would add another level of meaning to the tapestry. This stream of free asso-

ciations may have been triggered off by the word *aliya* in connection with the pioneers of the modern State or by the women bearing fruit and grapes who became part of the entry into Jerusalem. The result was the addition of a religious entry into Jerusalem to the historical ones—the *aliya* or "going up" to Jerusalem during the three pilgrimage festivals. During one of these holidays, Shavuoth or the Pentecost, the first fruits of the season were brought to the Temple. To reinforce the suggestion that the women carrying their baskets of fruit are indeed connected with this practice. Chagall added two women carrying sheaves of wheat, one of whom smiles at the spectator while standing close to a bearded man dressed in Chagall's "biblical" style. This is not just a harvest scene appropriate to the Feast of the Harvest but is highly reminiscent of Chagall's illustrations of the story of Boaz and Ruth, whose scroll is read on Shavuoth. Ruth's presence is doubly understandable here, as she is the immigrant to Israel and convert to Judaism whose faithfulness was rewarded when she not only achieved a happy marriage to Boaz but became the great-grandmother of David, whose entry into Jerusalem is depicted in the main scene in the tapestry.

The addition of one of the three yearly pilgrimages to Jerusalem seems to have spurred Chagall on to incorporate the other two. However, the entire central tapestry was already devoted to the second festival, Passover, symbolized by the Exodus and suggested here by the spies and their grapes. There remained then only one holiday to add, Succoth, the Feast of the

VISION OF JERUSALEM. DETAIL OF THE "ENTRY INTO JERUSALEM" CARTOON.

Tabernacles, and Chagall suggested it by adding a figure next to the musicians who stand in front of the Ark. At the extreme right border of his work, he placed a bearded man who had not been present in the preliminary drawing. He carries a lulav and an ethrog, the branch and fruit used ritually in the Succoth celebrations, and he, too, joins the crowd going up to Jerusalem.

The tapestry now had three levels of meaning: biblical history (David and the spies), modern history (the pioneers and the symbols of the modern State), and religion (the pilgrimage holidays). However, a complete representation of Jerusalem must take another level into consideration. Jerusalem is not thought of only as a temporal city, but as the incarnation of the Heavenly Jerusalem, the city of eternal peace. In order to add this conception of Jerusalem, Chagall returned to his Bible illustrations and combined two of them to create the circled vision of the walled city at the top of his composition. To fully understand the vision of Jerusalem around which the musicians and dancers move, we must turn to the texts Chagall had originally illustrated in his Bible drawings. The circled vision of Jerusalem was inspired by a prophecy of Isaiah:

Awake, awake; put on thy strength, O Zion; put on thy beautiful garments, O Jerusalem, the holy city; for henceforth there shall no more come into thee the uncircumcised and the unclean. Shake thyself from the dust; arise, and sit down, O Jerusalem: loose thyself from the bands of thy neck, O captive daughter of Zion. . . . How beautiful upon

the mountains are the feet of the messenger of good tidings, that announceth peace; the harbinger of good tidings that announceth salvation; that saith unto Zion, "Thy God reigneth!" Isaiah 52:1 — 7

Chagall combined this vision with another one by Isaiah which he had originally illustrated by juxtaposing a bride and groom to the Holy City:

For Zion's sake will I not hold my peace, and for Jerusalem's sake I will not rest, until her righteousness goes forth as brightness, and her salvation as a torch that burneth. And the nations shall see thy righteousness, and all kings thy glory: and thou shalt be called by a new name, which the mouth of the Lord shall mark out. Thou shalt also be a crown of glory in the hand of the Lord, and a royal diadem in the open hand of thy God. Thou shalt no more be termed Forsaken, neither shall thy land any more be termed Desolate; but thou shalt be called Hephzi-bah [my delight is in thee], and thy land Beulah [espoused]; for the Lord delighteth in thee and thy land shall be espoused. For as a young man espouseth a virgin, so shall thy sons espouse thee; and as the bridegroom rejoiceth over the bride, so shall thy God rejoice over thee. Isaiah 62:1 — 5

These prophecies of the future peace and security of Jerusalem find expression in the magic circle Chagall draws around his brilliantly lit walled city, whose spires and domes, as well as its massive walls and cypress and palm trees, immediately identify it for us. Before the walls a group of people stand at peace, protected from all the world, even from the joyous tumult of the musicians and dancers who lead the entry.

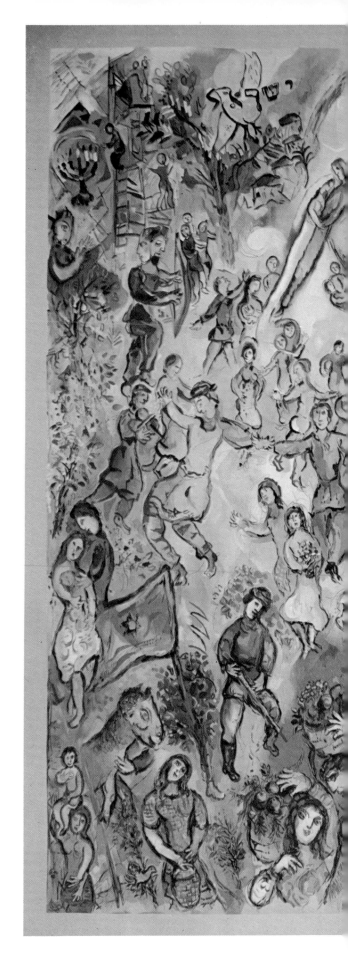

"ENTRY INTO JERUSALEM." TAPESTRY.
EXECUTED AT THE GOBELINS WORKS, PARIS,
BY M.E. LELONG AND ASSISTANTS.
15' 7" × 17' 4". 1964. 1968.

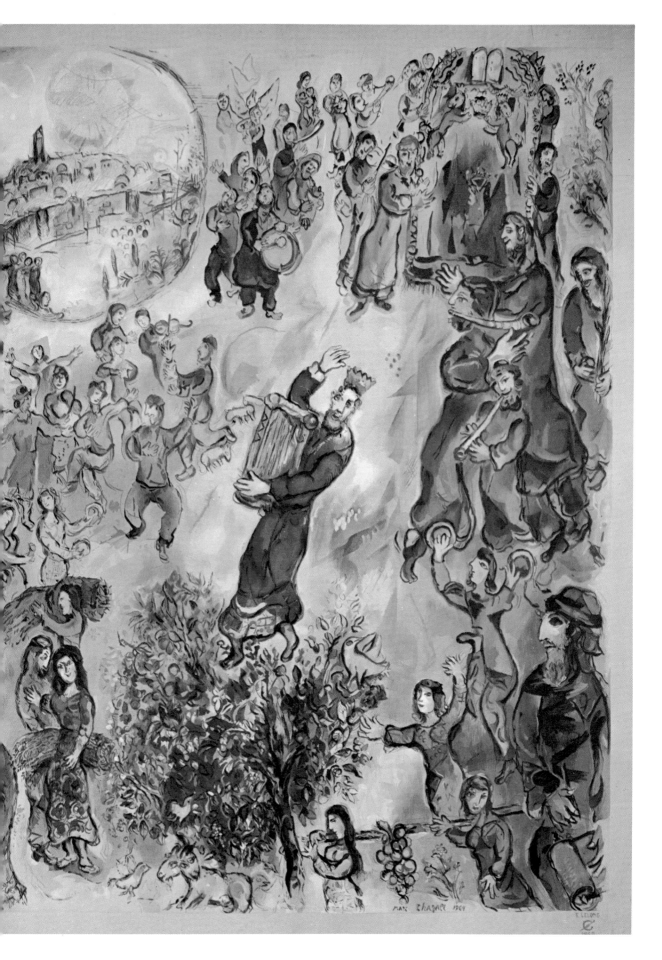

Marc Chagall 1964

Just below this circle lie two lovers, while a second pair of lovers, clearly dressed as the bride and bridegroom of Isaiah's prophecy, penetrate into the Holy City.

This idyllic representation of Isaiah's prophecies forms the keystone to Chagall's interpretation of the "Entry into Jerusalem," raising it from the historical levels, both biblical and modern, and the traditional religious level to that of prophecy. The "Entry into Jerusalem" here becomes the one that will end all wandering and exile, the permanent entry which will precede the coming of the Messianic period.

The visionary quality of the tapestry—the juxtaposition of past, present, and future, their intermingling and their religious significance—is consciously stressed by Chagall in the lower right-hand corner. Here he has painted a prophet clad in purple who gazes at the scene and transcribes his marvelous vision on the Torah scroll before him. Is he Isaiah, whose prophecy Chagall placed at the center of his work? If so, then David, Ruth, the spies, the Chassidim, the pioneers and the State of Israel are all part of this prophecy and give deeper meaning to his comforting words to the Exiles of Israel: Jerusalem in all its splendor shall be restored, and they shall return and enter the Holy City with all the joy that we see here before us, to live there in peace to the End of Days.

THE "ISAIAH'S PROPHECY" TAPESTRY

CHAGALL designed the "Peace" tapestry the year before he designed the other two, while he was working on another important commission, the Dag Hammarskjöld window for the United Nations Headquarters in New York. The "coincidence" of these two commissions strongly influenced the artist, who chose the same theme for both places, as it was appropriate for them not only individually but concurrently. In both cases the central theme is Isaiah's prophecy of Messianic Peace, clearly right for the United Nations, which was attempting to establish worldwide peace, and for Jerusalem, from whence, according to Isaiah, peace would issue forth. The differences between the two projects in format and color—the U.N. window is rectangular and basically blue, while the Knesset tapestry is almost square and primarily light green—were caused by the different settings each work would occupy. This was especially important in determining the details of subject matter, as the use of Christian iconography, which would be not only acceptable but expected in the United Nations, would create complications in Jerusalem. In examining the tapestry, we will do well to keep the U.N. window in mind, as it will help to explain certain details that otherwise might seem to be unconnected with the main theme.

ISAIAH. DETAIL OF THE "ISAIAH'S PROPHECY" CARTOON. GOUACHE. 1963.

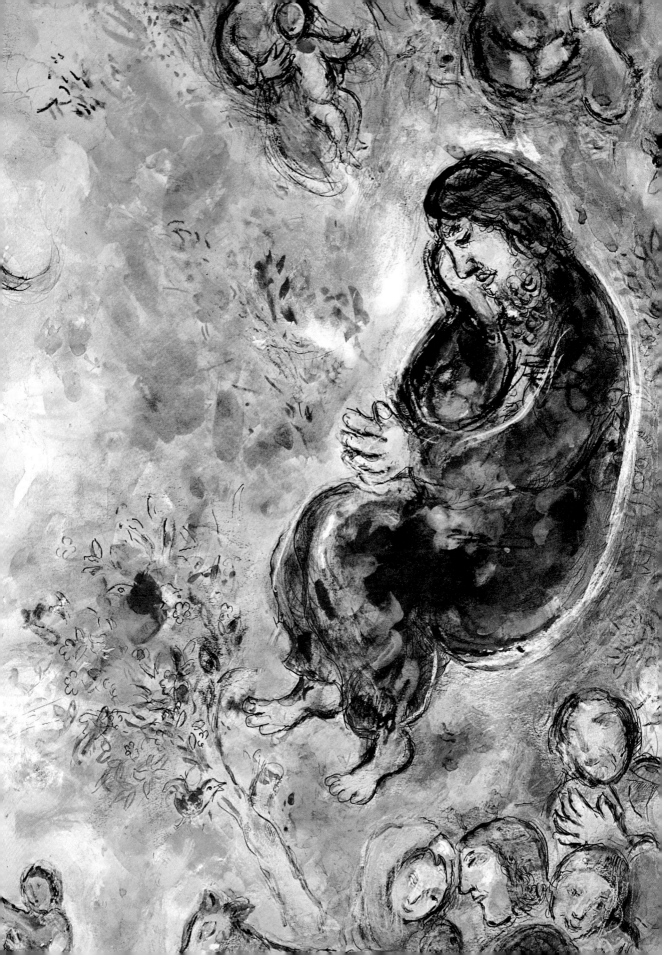

Isaiah's vision is well known, as it is important in both Jewish and Christian theology:

And the wolf shall dwell with the lamb, and the leopard shall lie down with the kid; and the calf and the young lion and the fatling together; and a little child shall lead them. And the cow and the bear shall feed; their young ones shall lie down together; and the lion shall eat straw like the ox. And the sucking child shall play on the hole of the asp, and the weaned child shall put his hand on the basilisk's den. They shall not hurt or destroy in all My holy mountain for the earth shall be full of the knowledge of the Lord, as the waters cover the sea. Isaiah 11 :6 — 9

As in his early illustration of this prophecy in the 1930's, Chagall here keeps very close to the text, although he made a few changes in the characteristics of the animals represented. From the first sentence, he chose a foxlike wolf (in orange, at the lower right), the smiling calf or fatling and the young lion and the kid, and between them, joyfully skipping along, the young child who would lead them. Above the kid, the cow and the bear appear side by side. Rather than simply feeding together, they seem to be on even more friendly terms, as the bear's paw lies on the cow's head while their children play exultantly at their feet. Here, too, a small child is added, as though to heighten the expression of peacefulness and the lack of any danger. To the right, a heraldic lion stands beside two small grazing animals, whose example he will shortly follow. Below to the right, a sucking child—an infant—extends

his arms toward the poisonous snake, who regards him thoughtfully.

All this takes place in a generally undefined area, a dream-space in which figures float one above another without any danger of collision. The feeling that emerges from it is Edenic, an atmosphere of a peaceful childhood of man and animals, of the emergence of life. This· expression had led many people to call the work "Genesis," but this is to some extent a misunderstanding of what is taking place. The scene before us is not a nostalgic reminiscence of the past, but a creative vision of the future. Its coming is heralded by the small man with a shofar in the center of the composition, whose image is reflected in the clouds of the vision as in a lake. That the tapestry really does describe Isaiah's vision is shown beyond doubt both by the repetition of the theme in the U.N. window, which has always been interpreted as a vision of peace, and by the text that Chagall cites for the original illustration in his book of Bible etchings.

Keeping close to this text, Chagall had from the start accepted the traditional interpretation of the child leading all these peaceful animals. He is thought to be the Messiah, and this is suggested both by the hint of the halo around his head, a residue of the clearly defined halo in the original etching, and by the mother and child lying in the lower left-hand corner. This interpretation is based on the rest of the prophecy, which begins:

And there shall come forth a shoot out of the stock of

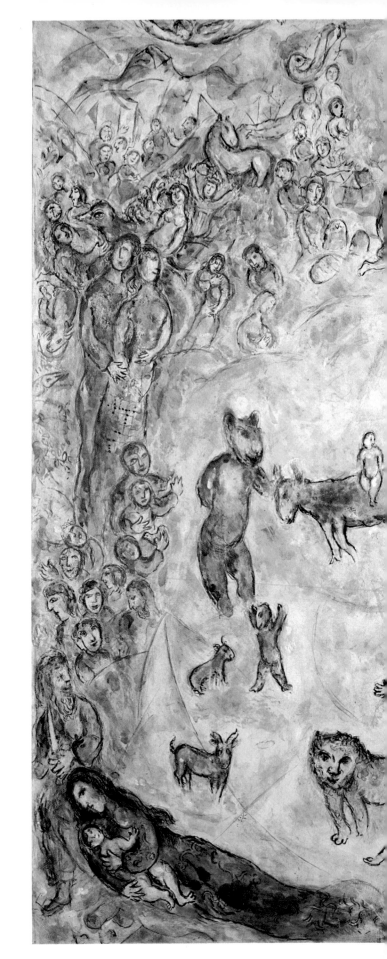

THE "ISAIAH'S PROPHECY."
CARTOON.
GOUACHE. 4' 2" × 4' 9". 1963.

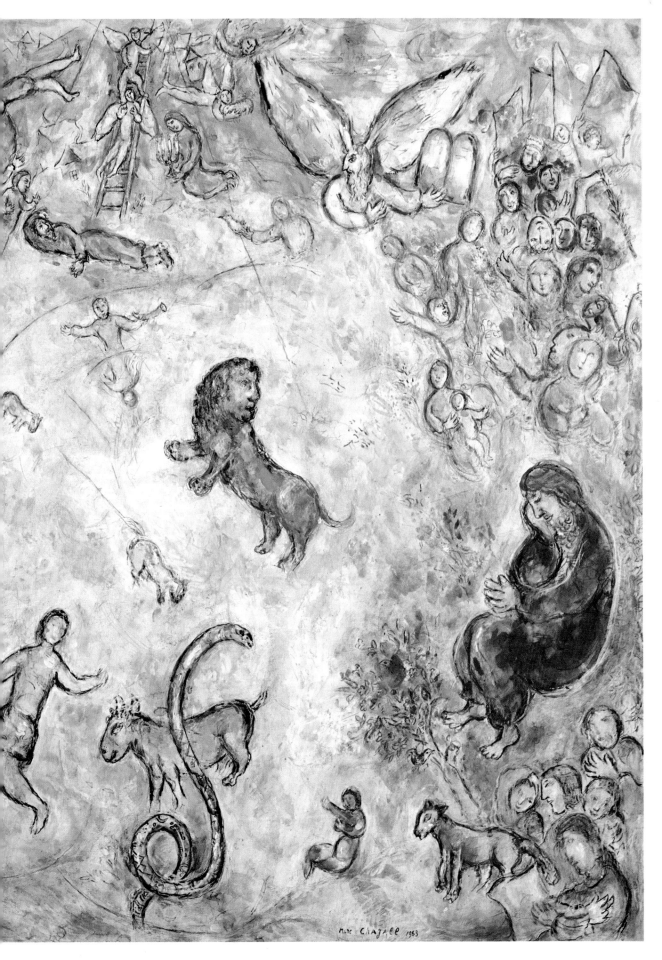

Marc Chagall 1963

Jesse, and a twig shall grow forth out of his roots. And the spirit of the Lord shall rest upon him, the spirit of wisdom and understanding, the spirit of counsel and might, the spirit of knowledge and of the fear of the Lord. And his delight shall be in the fear of the Lord; and he shall not judge after the sight of his eyes, neither decide after the hearing of his ears. But with righteousness shall he judge the poor, and decide with equity for the meek of the land; and he shall smite the land with the rod of his mouth, and with the breath of his lips shall he slay the wicked. And righteousness shall be the girdle of his loins, and faithfulness the girdle of his reins. Isaiah 11:1 — 5

After telling of the peace that shall reign under him, Isaiah continues:

And it shall come to pass in that day that the root of Jesse, that standeth for an ensign of the peoples, unto him shall the nations seek, and his resting-place shall be glorious.
 Isaiah 11:10.

On the right, above the infant and the wolf, Chagall literally depicted the "shoot" or "twig" coming forth from the root of Jesse as a flowering branch growing out of a broken tree stump.

The root which comes forth Jesse, who was the father of King David, symbolizes the longed-for Messiah—the Messiah, called the Son of David, who will put an end to strife and begin the reign of eternal peace. In Christian theology, this prophecy was interpreted as foretelling the coming of Christ and was linked to another line of Isaiah's prophecies: "Behold,

the young woman shall conceive and bear a son, and shall call his name Immanuel [the Lord is with us]" (Isaiah 7:14). The young woman and her son, connected to the "shoot from the stock of Jesse" by long tradition, here appear as a further indication of the messianic future pictured in the open area above them.

The mother and child seem to have been added originally in the sketches for the U.N. window, where Chagall followed the pattern he had established in his late biblical paintings and in his works for the Church at Assy and the Cathedral of Metz. In these works he had juxtaposed the Old Testament themes, which formed his main subjects, to related episodes from the New Testament in an attempt to blend the two Testaments together by suggesting continuity between them. This had been the reason he had added Christ Carrying the Cross to representations of the Sacrifice of Isaac, which in Christian theology prefigures the Crucifixion. This is also the reason he portrayed the Madonna and Child here in the corner of the prophecy Christians relate to the birth of Jesus. This motif was then adapted to the tapestry.

However, the interaction between the window and tapestry designs was not all one-sided. After establishing the mother and child in the tapestry, Chagall added a detail there which he then copied into the window design. Above the Madonna he placed a bearded man holding a knife, a strange detail in a work dedicated to peace. This venerable figure does not, however, appear to have any evil designs on either the mother

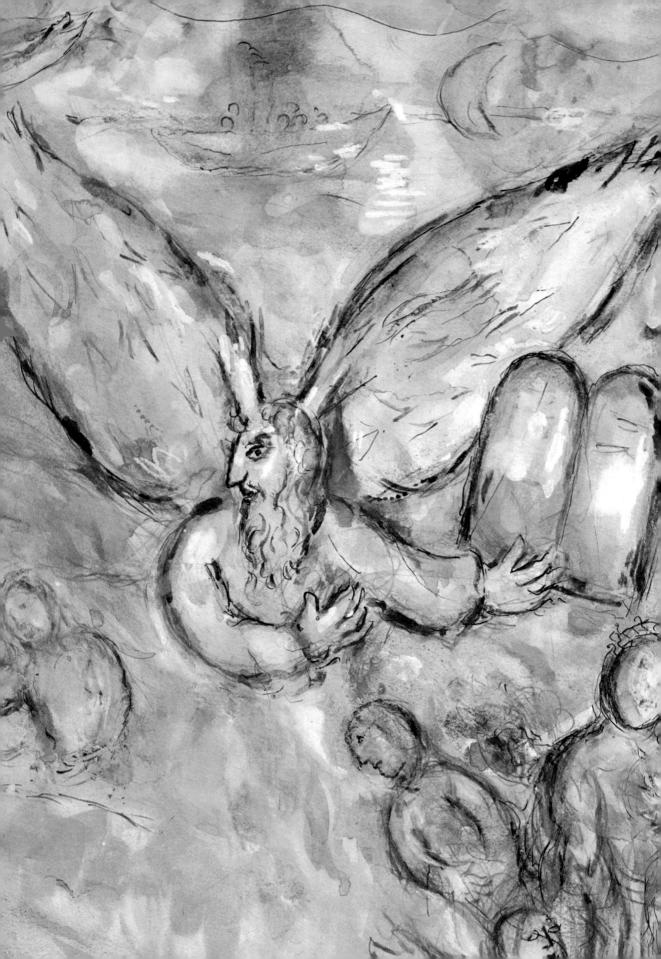

or the child, but suggests rather a *mohel,* a man who performs ritual circumcision on the eighth day after the birth of a boy. The addition of such a figure tends to stress the Jewish nature of the child born to the woman, so that a balance is achieved between the Jewish and Christian connotations of the theme. This "Judaization" would make the Madonna acceptable in Jerusalem and would lend a Jewish touch to the U.N. window, where it would also be acceptable, as Jesus had been circumcised.

For Jerusalem, Chagall seems to have wished to stress this figure to a much greater degree than in the U.N., where, in the final window, the knife is somewhat obscured by the leading pattern. He did not do so in the "Peace" tapestry itself, but rather by means of a device common to his work on the three tapestries as a set. Just as he had enlarged on the meaning of the David from the "Exodus" by repeating him in the wider context of the "Entry into Jerusalem," so he now picked up this figure of the *mohel* and gave it a much deeper meaning by copying it, reversed, into the right side of the "Exodus," where it becomes the figure of Abraham about to sacrifice Isaac. The pose of Abraham in this scene had been new for Chagall, as had the cruciform pose of Isaac. The two scenes, that of the Madonna and the *mohel* and that of Abraham sacrificing Isaac, are set almost side by side, one above the other in the final arrangement of the tapestries, so that the connection between them is stressed visually. In this juxtaposition, Chagall was again emphasizing the interrelationship between Judaism and Christianity:

MOSES. DETAIL OF THE "ISAIAH'S PROPHECY" CARTOON. GOUACHE. 1963.

81

in one case he Judaized the Madonna and Child, and in the other Christianized Isaac.

This relationship between the two Testaments may at first seem offensive to Orthodox eyes, but it should not be, because it stems from Chagall's own unique and personal understanding of Christ, whom he sees as the symbol and epitome of the Jewish martyr. This identification had developed in Chagall's work in the late 1930's, when in an attempt to convey the enormity of the coming extermination of the Jews to the Christian world, he had portrayed the crucified Christ as a Jew, wrapped in a *tallith* (prayer shawl) or wearing *tefillin* (phylacteries), and clearly designated in Hebrew and Latin as the King of the Jews. Around this pathetic figure, pogroms raged, synagogues burned, boats sank, and the fleeing Jews sought to protect their most valued possessions, the Torah and their children. It was at this time that the Madonna and Child made their appearance in Chagall's work, usually in representations of the Flight into Egypt, as symbols of the Plight of the fleeing refugee mothers who were doing everything they could to protect their children from the horrors of the concentration camps.

This personal view of Christ as a Jew is the motivation behind Chagall's need to combine the two Testaments, not only in works designed for the Church but in his own biblical paintings. It is also to a great extent the cause for his placement of Moses holding the Tablets of the Law and the Crucifixion side by side in the United Nations window. This was a combi-

nation he had also planned for the top of the Jerusalem tapestry, as is evidenced by a number of early sketches. However, it was pointed out to Chagall that, personal symbolism aside, he could not place a Crucifixion in Israel's Knesset. Moses, winged and pointing to the Ten Commandments, could remain and would be enlarged upon in the "Exodus" tapestry, but a substitute must be found for Christ.

This was no mean problem, as it involved not only finding a substitute who would fit in with the meaning of the tapestry, but one who would produce the horizontal and vertical lines Chagall felt he needed at the top of his composition. After several unsucessful attempts, which apparently included adding the Sacrifice of Isaac to the Crucifixion, in an attempt to "Judaize" it, and substituting King David playing his lyre for Christ's vertical form, Chagall found his solution. He added Jacob's Dream to the top center of his composition, portraying the sleeping Jacob in a horizontal position and the ladder on which the angels ascend to and descend from Heaven in a vertical one. The idea of substituting Jacob for Christ may have been inspired by the motif of the ladder, as a similar ladder had been present in his treatment of the Crucifixion—it is the ladder used to help remove Christ from his cross.

Beside Jacob's ladder Chagall set several other figures who seem almost to form a united scene with it: one holds a menorah, while another sends forth a bird; an angel carries a lamb or ram; and finally an angelic, winged Moses presents the Ten Commandments. All

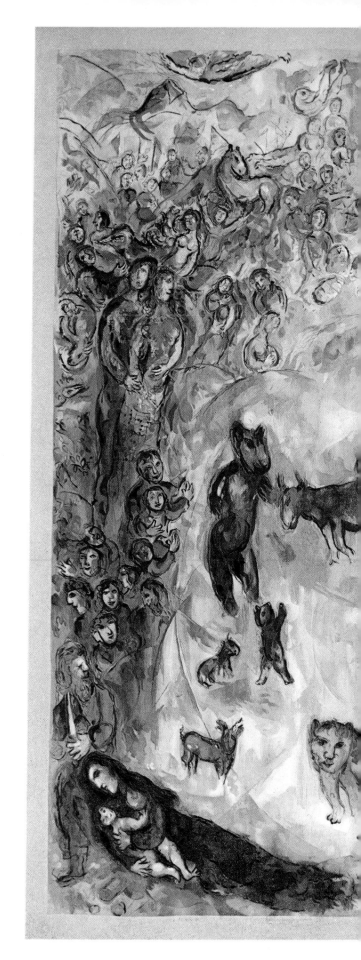

"ISAIAH'S PROPHECY." TAPESTRY.
EXECUTED AT THE GOBELINS WORKS, PARIS?
BY M. E. MELOT AND ASSISTANTS.
15′ 7″ × 17′ 6″. 1964–67.

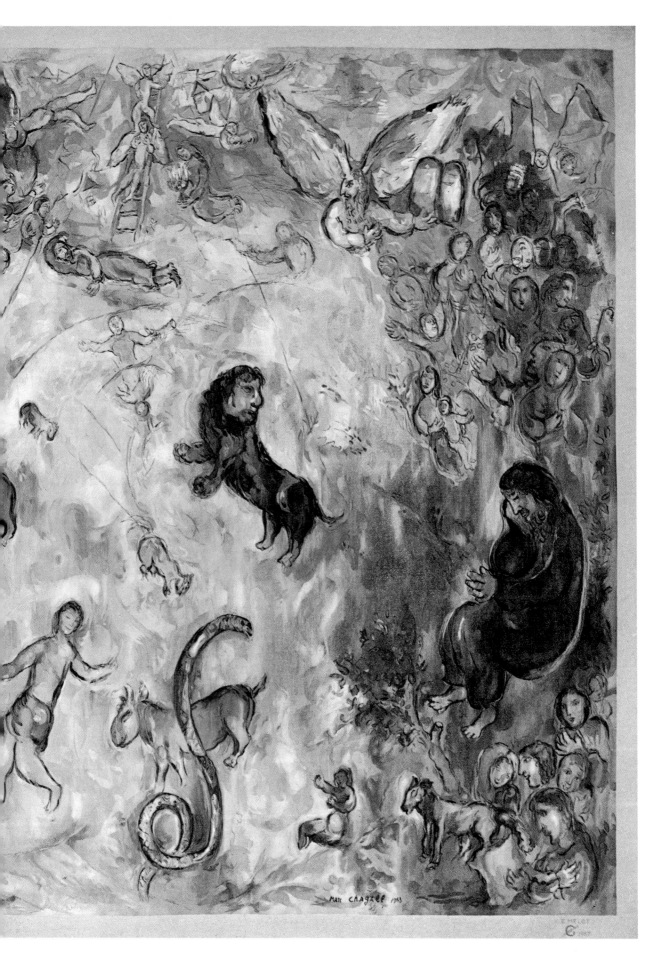

Marc Chagall 1963

of these figures reflect covenants between man and God. Jacob's dream, which illustrates graphically the contact between the human and divine spheres, preceded the covenant God made with Jacob promising him that the land of Israel would be given to his offspring (Genesis 28:12 — 15).

The angel carrying the lamblike ram is connected with the sacrifice of Isaac, as a midrashic legend explains that an angel had brought the ram who suddenly appeared before Abraham's eyes. Here again the act involved, the planned sacrifice of Isaac, preceded God's blessing of Abraham and his offspring.

The man dispatching the bird is Noah sending the dove forth to see whether the flood had abated. Again, this act preceded a covenant, that between God and Noah in which God promised never again to try to destroy the earth and all its creatures (Genesis 8:21 — 22).

Finally, Moses and the Tablets of the Law symbolize the agreement between the Children of Israel and God on Mount Sinai, and Moses' wings indicate the divine nature of the commandments they agreed to obey. All these figures revolve around a figure holding a pronounced symbol of Judaism, the menorah, the symbol God instructed the artist Bezalel to make and place in the Tabernacle.

This section of the tapestry shows Chagall's thorough replacement of his initial Judaeo-Christian symbols with manifestly Jewish ones, all of which stress God's contact

with man, and specifically with the men of the Old Testament.

It is from this point onward that the plans for the tapestry and for the U.N. window diverge sharply. In the window not only does Christ appear, but Chagall added elements which were particularly appropriate to the U.N. and to the memory of Dag Hammarskjöld. For instance, above the vision of peace, instead of Jacob, Chagall painted a Pietà—a mourning over the dead Christ—an analogy to the mourning over Dag Hammarskjöld who had died tragically in a plane crash in 1961, plummeting from the skies like the red-winged angel who falls beside the Pietà. Around the vision people go happily about their business, read books, dance, collect flowers, and meet in large cities in peaceful and learned conversation at the foot of the cross.

Although, at first glance, the people congregating around the vision in the tapestry resemble those in the window, they have another meaning. With them Chagall returns to Isaiah's prophecy, this time depicting the end of it:

And it shall come to pass in that day, that the Lord will set His hand again the second time to recover the remnant of His people, that shall remain from Assyria, and from Egypt, and from Pathros, and from Cush, and from Elam, and from Shinar, and from Hamath, and from the islands of the sea. And He will set up an ensign for the nations, and will assemble the dispersed of Israel, and gather together the scattered of Judah from the four corners of the earth. . . . And there shall be a highway for the

remnant of His people that shall remain from Assyria; like as there was for Israel in the day that he came up out of the land of Egypt. Isaiah 11:11 — 12, 16

This prophecy is fulfilled on both sides of the vision. Starting from the falling angel with the flaming wings near Jacob's ladder, we can detect a scene of desolation—burning houses, broken Jewish tombstones, and mourning women. The falling angel here becomes a symbol of the Holocaust from which the people below escape, along with their household animals, birds, and fish, in couples and singly, smiling and completely trusting in the peace promised them in the future. They are guided by the angel flying overhead, at the top of the tapestry, another symbol of divine care for this ingathering of the exiles. On the right more returning exiles are grouped, waving the flags or ensigns mentioned in the prophecy and carrying their treasured possessions—a Torah scroll and a child. Here, as in the "Exodus," Chagall is not dealing with the exiles to the countries named by Isaiah, but with the modern ones who return to the Land of Israel.

In the middle of this side of the composition, with its gleeful returning people, sits the prophet Isaiah, whose vision is the central theme of the tapestry. Here again a comparison with the U.N. Window will prove interesting, as instead of smiling broadly on beholding his vision, as he does there, the Isaiah of the tapestry closes his eyes and lifts his hand to his cheek in the

age-old gesture of sorrow. At his feet there is a broken stump from which grows a flowering branch symbolizing the Messiah. Perhaps in his marvelous vision of the future, he has realized that it is only the *remnant* of the people who would be saved, and his sorrow echoes the symbols of the Holocaust at the upper left. This addition of a sorrowful memory in the midst of joy is typical of Judaism and recalls, for instance, the breaking of a glass at a wedding ceremony in memory of the destruction of the Temple. Isaiah's mourning gesture does not deny the joy of his vision but, by forming a contrast to it, serves to intensify the happiness and peace that he foretold.

This tapestry, which was the first to be planned and executed, completes the cycle of the three tapestries but does not end it, as each composition leads directly to the next. If we start from "Peace," we will be led to "Exodus" thematically and visually. The figures of Moses and Abraham in the "Exodus" are prefigured here, and the whole theme of the return of the exiles, the combination of biblical past and historical present, will be enlarged upon and will become the main theme of the central tapestry. The goal of the "Exodus" —Jerusalem—will then be taken up and expanded in the "Entry into Jerusalem," again interpreted on several different levels. But the "Entry" ends with Isaiah's messianic vision of Jerusalem and Israel's return to her, and that prophecy encircled at the top of the third tapestry leads us back to that other similar prophecy of Isaiah, "Peace," the main theme of the first tapestry.

This unending cycle, spread over the Knesset walls in
the form of a triptych thus not only gives us a historical
summary of Israel's relationship to God and to the

PRELIMINARY STUDY FOR "ENTRY INTO JERUSALEM." 1963 – 64.

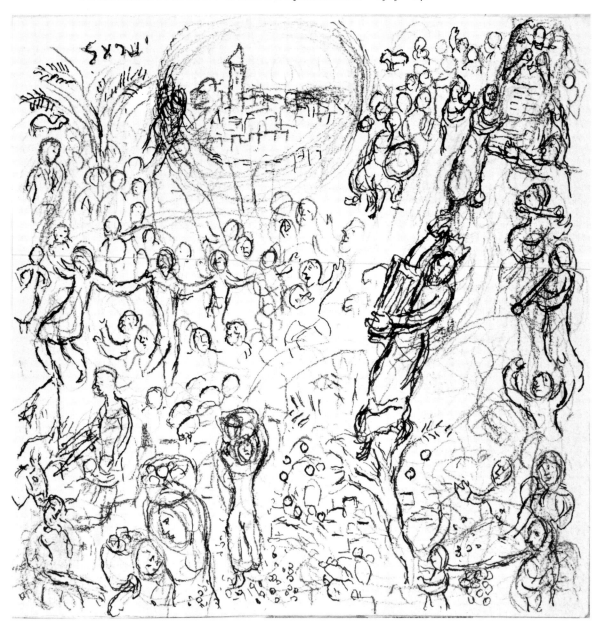

Land of Israel, but begins and ends with a vision of
peace, which will issue forth from Jerusalem to encompass
the rest of the world.

PRELIMINARY STUDY FOR "ISAIAH'S PROPHECY". 1963.

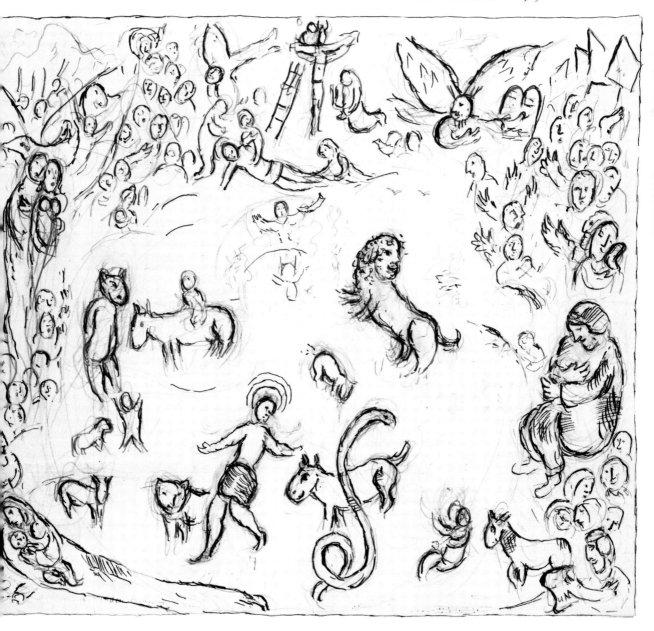

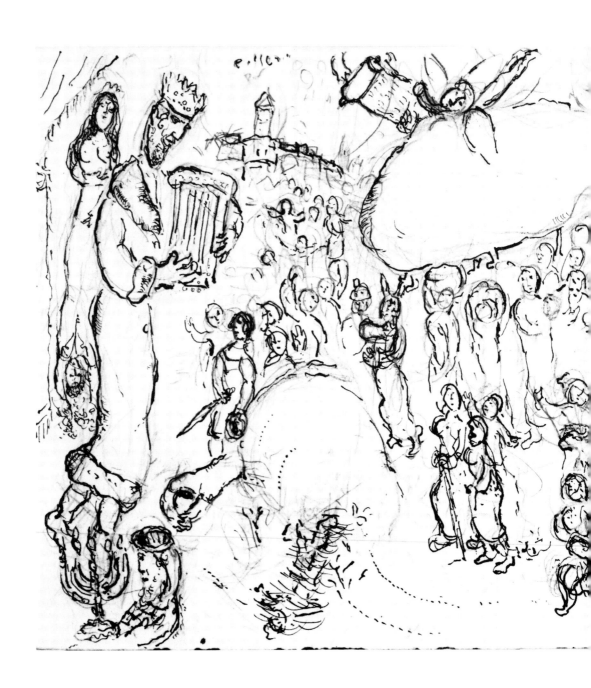

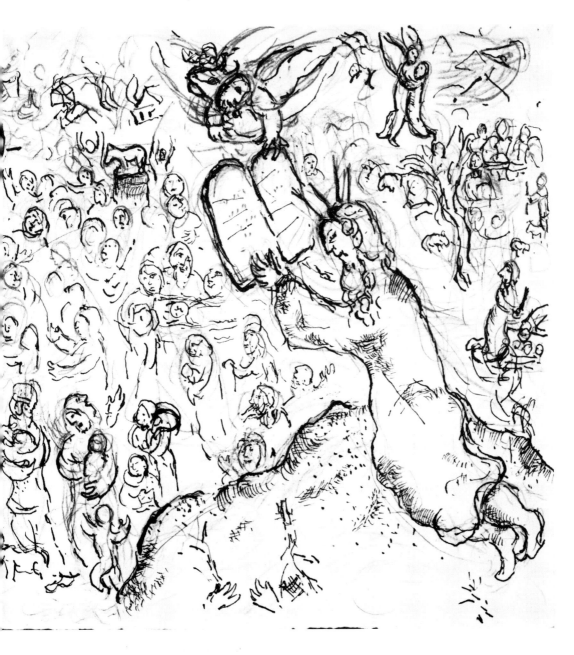

PRELIMINARY STUDY FOR "EXODUS." 1963.

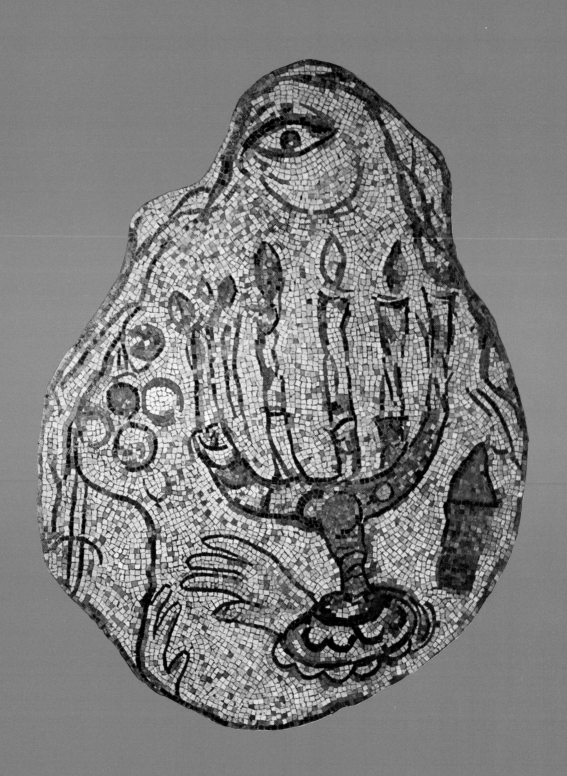

THE FLOOR MOSAICS

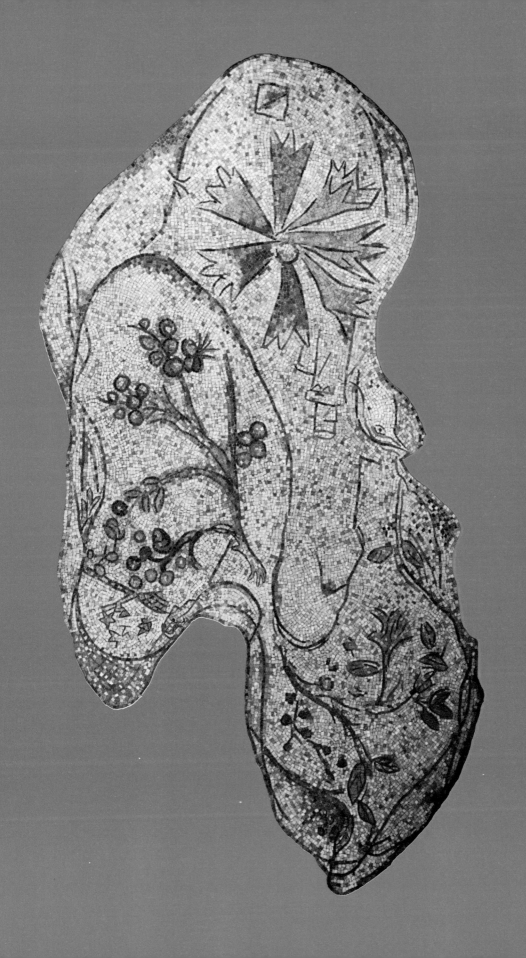

As opposed to the carefully thought out tapestries in which every detail is significant and is clearly delineated in the highly finished cartoon, the floor mosaics were drawn by Chagall with a sketchy line which suggested rather than stated his ideas. This was not due to laziness on the part of a busy artist, but is rather an indication that his conception of the mosaics lay in the meaning of the composition as whole rather than in the details of each isolated fragment.

Chagall's original idea for the floor carries through extremely well in the finished mosaic. Twelve highly irregularly shaped fragments are scattered loosely over the floor with no specific pattern which can be easily grasped by the spectator. Strolling around the hall, one constantly discovers still another fragment, each one set in at a different angle than its neighbor and with its figures facing in the opposite direction. These strange, almost broken shapes contrast strongly with the checker-board of solid square marble blocks around them. The mosaics immediately bring to mind the irregular, literally broken remnants of synagogue mosaic floors from the fifth to sixth centuries of our own era that have been discovered during the past century by archaeologists, primarily in Israel.

These synagogue mosaics usually show the signs of the zodiac, the animals and birds of the region, and occasionally Jewish symbols such as the Ark of the Law *(Aron Hakodesh),* the shofar, and the menorah. More rarely, for instance at Beit Alpha, important biblical scenes, such as the sacrifice of Isaac, are illustrated in fairly great detail. These mosaic floors are important indications of the existance of Jewish art at a very early stage, despite the strong biblical injunction against plastic art contained in the second commandment. Although it had long been accepted that there was no Jewish art before the manuscript illustrations of the late Middle Ages, and that even they were based on Christian art, some scholars had asserted that the second commandment had not been understood as strictly forbidding art even while the Children of Israel were still wandering around in the desert. To prove this assertion they brought forth the example of the cherubim which God ordered Bezalel to sculpt atop the Ark of the Covenant (Exodus 25:10 — 20) as well as Solomon's decoration of the Temple, which included not only another two cherubim (I Kings 6:23 — 29), but twelve oxen who held up the large basin called the molten sea (I Kings 7: 23 — 25). However, until the discovery of the wall paintings in the synagogue at Dura-Europos in Asia Minor and the mosaics of synagogue floors in Israel, these experts had no actual visual proof that such a Jewish art had in fact existed.

Chagall had been interested in Jewish art almost since the beginning of his career, both in creating it

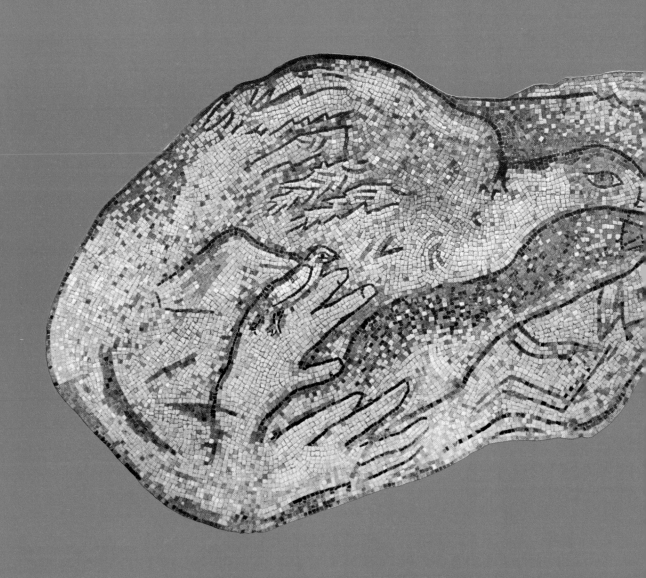

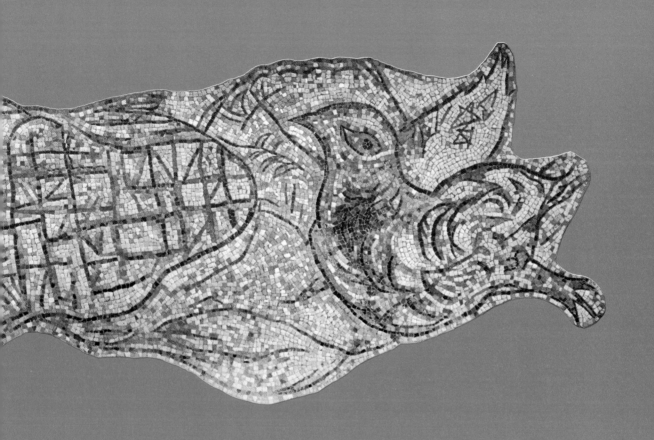

and in discovering its past. He had adopted as a great-grandfather the great Jewish artist of the eighteenth century Chaim Segal, who had painted the ceiling of the Mohilev synagogue in White Russia, and at an early stage had begun to debate within himself the possibilities of a Jewish contribution to the plastic arts. He was actively involved with the revival of the Jewish arts in Russia after the 1917 Revolution and became friendly with one of its leaders, El Lissitsky, who had made a copy of the ceiling of the Mohilev synagogue. Chagall had even invited Lissitsky to teach in his art academy in Vitebsk. It is not surprising that it was in Vitebsk in 1920 that friends of Chagall, M. Yudovin and S. Malkin, published a folio of linocuts entitled *Jewish Folk Ornament* in which they copied paintings from tombstones, mizrach tablets, and other ritual objects. This type of art and that on menorahs and in medieval manuscripts had been the Jewish art on which Chagall had built, especially when he had been given a Jewish commission such as the Hadassah windows. This type of art, basically a folk art with a touching naivity that has a direct appeal, was much loved by Chagall not only for its Jewishness, but specifically for its unlearned, almost childlike quality.

The same childlike simplicity and folk character could be found in the ancient mosaic floors, especially in that of Beit Alpha. Although Chagall had apparently been aware of these mosaics and had seen them in passing during previous visits to Israel, he had made a special tour of the Antiquities Department of the Archaeological

Museum when he had visited Jerusalem to discuss details of his tapestry decorations in December 1963. The mosaics he saw there had made a strong impression on him and were no doubt responsible for his decision in mid-1964 to add a mosaic decoration to the marble floor of the Knesset gallery. The inspiration was not only in the idea of such a mosaic floor, but in the concept of scattered mosaic remnants set laboriously into the squared-of marble floor blocks, which had to be cut to match the irregular outlines of the fragments exactly. That he chose this pattern rather than square blocks of mosaic or a central or a border design is a sure indication of the idea the artist wished to convey to the spectator.

The subjects Chagall chose are those he had found in the synagogue mosaics. He depicted birds flying among branches of fruit, often freed by hands just visible at the edge of the mosaic fragment, in a manner strongly reminiscent of Noah sending the dove forth from the ark. In one of these fragments—that signed by Chagall in Hebrew—one of the birds wanders among two columns as though it had strayed into the *Aron Hakodesh* by chance while two others play around a toothy mouth trapped in a maze of lines. Other fragments show pastoral scenes with animals grazing and baskets full of fruit and flowers. Still others show the kind of Jewish symbols typical of ancient synagogue floors. Aside from the *Aron Hakodesh,* we can find a shofar supported by a hand and surrounded by fruit and a menorah which has five branches but the tradi-

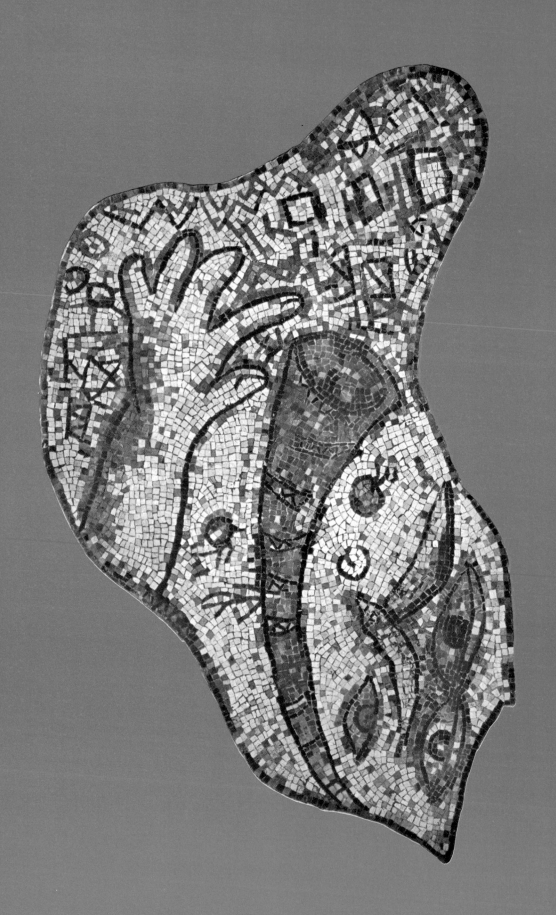

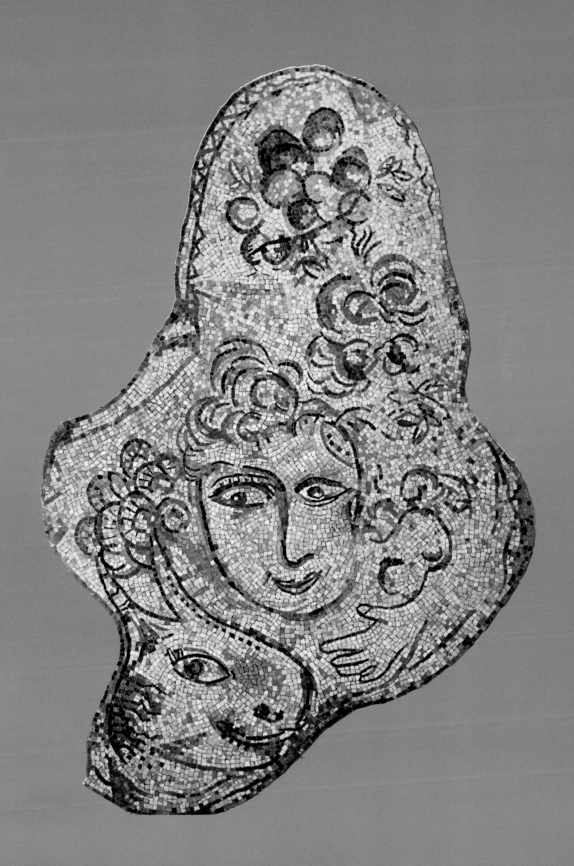

tional seven flames. The menorah is set beside two hands raised in a position which recalls the priestly blessing, fruit, and a small pointed box which seems to be a combination of the spice-box now used in the ceremony at the end of the Sabbath and the ritual utensil found beside the menorah in Beit Alpha and Huldah. Both the shofar and the menorah are watched over by divine eyes, an almost superstitious protection against evil. In still another fragment a large seven-point star of the type found in medieval Bible tables rotates in a pastoral setting in which a Chagallian head appears near the border. The only other head depicted is of a smiling, curly haired younth set beside an equally happy animal done in a style very reminiscent of the servant and donkey who accompany Abraham and Isaac in the mosaic at Beit Alpha.

In none of these mosaics does Chagall actually copy the ancient art of the synagogue, but rather he creates his own ancient art fragments. This is true not only of the individual subjects portrayed, but of the style which is as Chagallian as ever and has as many similarities with the paintings of the Mohilev synagogue as with the mosaics of the Holy Land. Some of his inspiration seems indeed to have come from his own stained-glass windows at the Hadassah Medical Center in Jerusalem. Here, as there, his decoration is divided into twelve parts, but here they are connected neither with the twelve tribes of the windows nor with the twelve zodiac signs of the ancient floors. As at the Hadassah Medical Center, he based his decoration

primarily on animals, birds, flowers and fruit, and a few Jewish symbols, although in the floor he allowed himself to draw in two human faces. Many of the birds and animals in fact seem to have wandered in from his windows, bringing with them the angular leading pattern of the stained-glass panels.

Chagall thus connected his floor mosaic with some of the oldest examples of synagogue art in existence as well as with his own contribution to modern synagogue art. This association of ideas, however, does not work only on the level of Chagall's search for a Jewish art on which to base his own art. He never forgot for a moment that he was designing the Knesset floor, and his choice of ancient synagogue remnants has a deeper significance specifically appropriate to its location.

These mosaics symbolize both the existence of a high Jewish culture in the Holy Land in the far past and its rediscovery by present day Israel. Indeed, digging up the archaeological past is more than just an Israeli national past-time to which its generals, from Yigal Yadin to Moshe Dayan, are addicted. It is a reaffirmation of modern Israel's connection with its historical past in the Holy Land and an attempt to learn what were the actual day-by-day facts of existence of that past. This "research" is not purely an enthusiasm for uncovering history for its own sake. It is an attempt to understand the life of the ancestors of the modern Jew in order to learn from them the ways of solving present-day problems, which are not all that different in the long view from those of the past. It also results

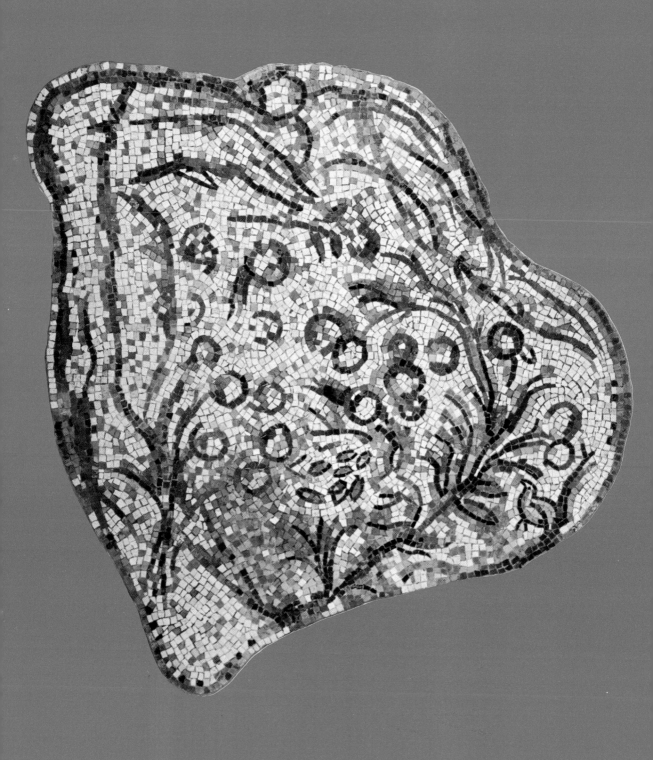

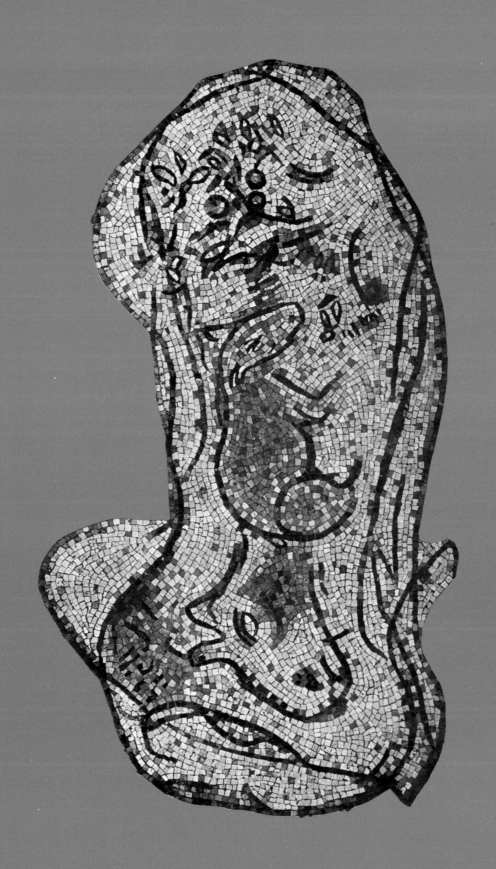

from a wish to discover how to avoid the mistakes that led to the destruction of the First and Second Temples, a wish that has contributed a great deal to the motto: "Masada shall not fall again."

This identification of past and present rather than a strictly archaeological fervor is behind what may almost be termed the "cult" of Masada, the last stronghold of an independent Jewish State, destroyed by the Roman legions in A.D. 73. This "cult" led not only to the dispatch of the Masada archaeological exhibition around the world, but to the practice of taking young soldiers to the top of the Masada tel to swear allegiance to the State as part of their official induction into the army. Such archaeological remains also serve Israel as a proof of her right to exist in her ancient homeland, proof which is needed to convince a sceptical world, unwilling to accept the Bible's testimony that this was indeed the Promised Land of the Jewish people and their home for a period of over a thousand years. Only if we understand the profoundly emotional impact of these archaeological discoveries on the Jews now living in Israel, can we grasp the effect Chagall wished to create on them by means of his floor.

Chagall's program for the Knesset floor is thus clear, both in its personal and national connotations. The mosaic fragments testify to the rediscovery of Israel's past as a State living on its own lands, a rediscovery that was made in modern times when Israel again occupies these same lands. It testifies to the ties between that ancient culture and that of the modern State.

Mixed in with this is Chagall's parallel rediscovery of ancient Jewish art and its connection to his own modern art.

Chagall chose the remnants of synagogue art as his leit-motif, however, not only because it interested him in terms of his *art* roots in the distant past, but because, as *synagogue* art, it specified a particular type of Jewish culture, religious rather than secular. This gives a special spiritual coloration to the cultural past discovered by the archaeologists and to its ties with the present. It is this spiritual Jewish culture which Chagall lays down as the basis or literally "floor" of the Knesset, a constant reminder to the governing body of the present State, whose decisions must take the past into account in order to determine Israel's future.

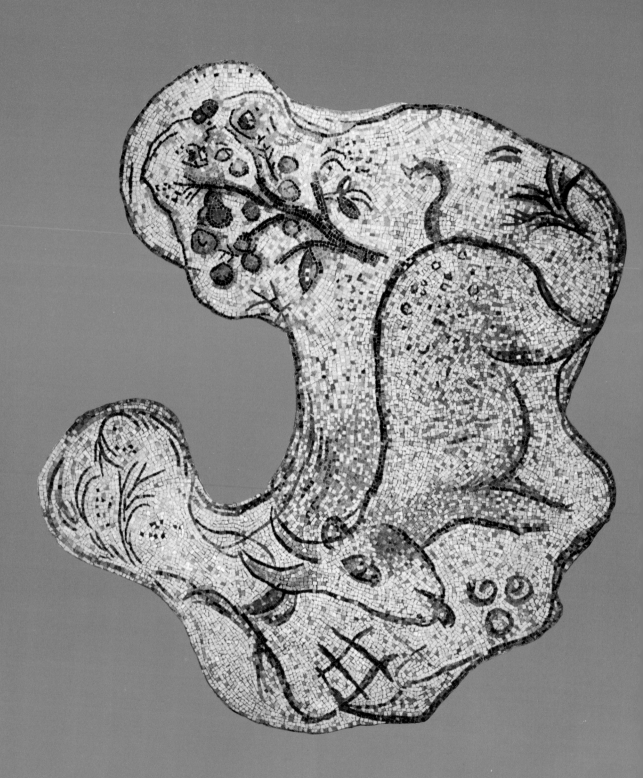

"THE WESTERN WALL" MOSAIC

PRELIMINARY STUDY FOR THE "WESTERN WALL" MOSAIC.

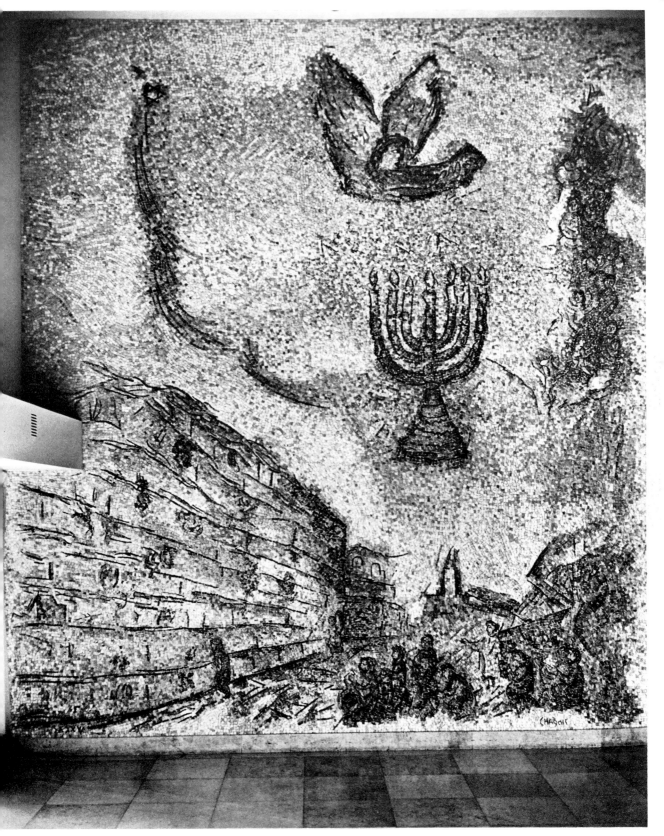

"THE WESTERN WALL" MOSAIC.

JUST as Chagall used ancient mosaic floors as the leit-motif for the Knesset floor, so he chose a wall as the subject of his wall mosaic—the Wailing Wall. This wall, part of the western wall of the enclosure of the Second Temple compound, was traditionally held to be close to the ruined Holy of Holies, as close, in fact, as it was possible to go without setting foot on the Temple mount itself. During most of the period after the destruction of the Second Temple by the Roman legions under Titus, Jews had been banned from the Temple area and often needed special permission even to approach its gates. During this time, the western wall became a symbol of the Temple, the site to which pilgrims flocked on every occasion, and in the eleventh century special prayers were even composed to be recited when visiting it. Periods in which Jews were barred even from this small area were times of mourning and frustration, perhaps none more so than the years between 1948 and 1967, during which Jerusalem was divided and, although Jews had regained possession of their land and the Wall was within a five minute walk from the border, the Wall remained as inaccessible to them as the moon.

Chagall's representation of the Wall had been inspired by one of the subjects suggested to him by Kadish Luz for the tapestries, Psalm 137:

By the rivers of Babylon, there we sat down, yea, we wept, when we remembered Zion. Upon the willows in the midst thereof we hanged up our harps. For there they that led us captive asked of us words of song; and our tormentors asked of us mirth: " Sing us one of the songs of Zion." How shall we sing the Lord's song in a foreign land?

If I forget thee, O Jerusalem, let my right hand forget her cunning. Let my tongue cleave to the roof of my mouth if I do not remember thee; if I sit not Jerusalem above my chiefest joy. Psalms 137:1 — 6

Although Chagall had dealt with Jerusalem in great detail in the tapestries, nothing he had done really expressed this psalm, whose words have become a pledge of allegiance of Jews since the destruction of the Temple and the inspiration for many poems and paintings. Chagall had depicted the joy of the return to Jerusalem, but not the yearning for that return, the feeling that the exile had not yet ended despite the establishment of the State. The artist had already hinted in the "Prophecy of Isaiah" and in the "Entry into Jerusalem" that the return from exile was not yet complete. In the latter, Jerusalem itself is still an encircled dream reached only by the biblical bride and groom. In "Peace," Isaiah sits near his vision grieving. This was compared to the note of sorrow sounded in the midst of joy by Jews in memory of the destruction of the Temple, an idea that dates back at least as far as Talmudic times. But these hints were not enough, as they would not immediately be understood by the public, and that was a major point in Chagall's Knesset decorations. As with other

details suggested in the "Peace" tapestry, he enlarged on this idea in another part of the decoration—the mosaic wall.

In interpreting the feeling of longing behind Psalm 137, Chagall did not consider painting a literal depiction of Jews mourning beside the rivers of Babylon, hanging their harps on the willows as other artists had done. Rather he got to the core of the matter: he must create a symbol of "If I forget thee Jerusalem," and the symbol presented itself ready to his hand—the Western Wall, the wall of tears and longing. Chagall had undoubtedly seen many pictures of the Western Wall and had even painted it himself during his first visit to Israel in 1932. In his new interpretation of it he seems to conform to tradition, stressing the moss growing between its massive Herodian stones and the people praying at the wall, either standing close to it or gazing at it over their open books while seated a short distance away.

However, after looking at the mosaic for a while, today's spectator may begin to ask a few questions. The mosaic wall was designed in 1966, a whole year before the Seven-Day War, and at that time the area before the Wall looked differently than it does in Chagall's mosaic. Owing to the narrow streets and crowded living quarters of the old city, there was very little space between the wall and the houses almost encroaching on it, certainly not the wide plaza Chagall depicted. Yet, in his 1932 painting, he had described the space before the wall accurately as a narrow passage-

way between buildings, one side of which is the Wall itself. Furthermore, in the background of the mosaic behind the wide plaza and its tree, a tower can be seen, which calls to mind the Tower of David. As the tower is on the other side of the old city, near the Jaffa Gate, it cannot possibly be seen from the Wall.

The reason for these changes is simple. Chagall, symbolizing the centuries-long yearning for a return to Jerusalem and even for a Third Temple, was not interested in an accurate depiction of the Wall. He wanted a vision of it, a vision which would include that other symbol of Jerusalem, David's Tower, which he had already set into both his representations of Jerusalem in the tapestries. This vision was also a yearning for a reunited Jerusalem in which the space would have to be enlarged in front of the Wall to form a spacious plaza which could encompass the multitudes who would flock to the Wall.

The dreamy blue-green tones of the mosaic express its visionary character as do the objects and figures which appear miraculously suspended above the plaza. In the center, the gold and orange flames of the menorah glow brilliantly. Chagall had represented the menorah three times in his art for the Knesset, expressing the various aspects of this symbol. In the "Exodus" tapestry, it had been set beside Aaron in the section dedicated to Jerusalem and clearly referred to the menorah created by Bezalel during the Exodus, according to God's instructions, and housed first in the Tabernacle and then in Solomon's Temple. In the

"Entry into Jerusalem," it had been fitted into an area dealing with the pioneers of the modern State of Israel and alluded to the official seal of that State. In the mosaic floor, he had used the menorah as the most common Jewish symbol from the destruction of the Second Temple until the eighteenth century when it was replaced by the six-pointed Star of David. In the mosaic wall, Chagall combined all these meanings in one of the most exact renderings of the menorah that he has ever done. It is both a symbol of the State and, set beside the Western Wall, a reference to the original menorah housed in the Temple. As such, it is reaffirmed as a primary symbol of Judaism.

This combined religious-national symbol sets the tone for the rest of this area of the mosaic wall. Above it, an angel blows a shofar, calling on the people streaming down to the Western Wall on the left to return to Zion. Again Chagall had turned to Isaiah for inspiration:

And it shall come to pass in that day, that a great horn [Shofar] shall be blown; and they shall come that were lost in the land of Assyria, and they that were dispersed in the land of Egypt; and they shall worship the Lord in the holy mountain at Jerusalem. Isaiah 27:13

As in his other interpretations of Isaiah's prophecies, he does not take it as referring only to the exiles of the First Temple, for whom Isaiah's words were meant, but to all Jewish exiles, especially those of the present day whom the angel calls on to return to Jerusalem and the Temple Mount.

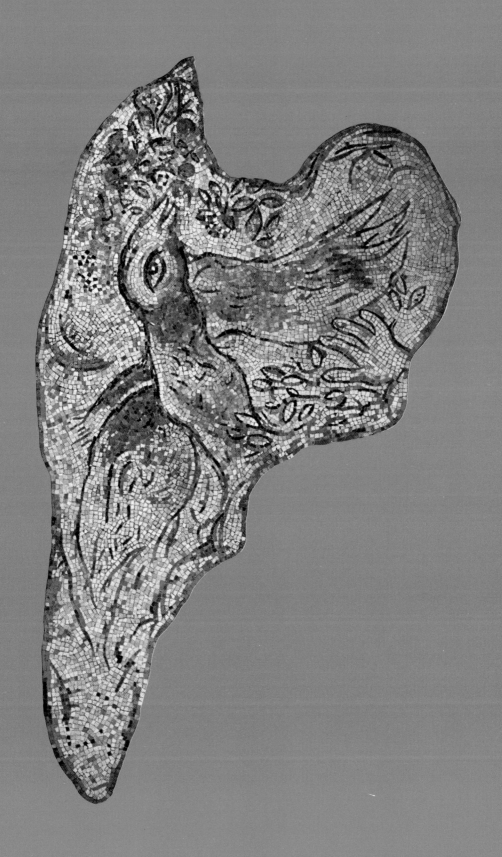

But here again Chagall realized that this prophecy had not yet been fully attained. On the left of the angel, he depicted a Star of David in full flight in lines which complement those of the incoming exiles. Here he was representing another prophecy which has messianic overtones, the words of the foreign prophet Balaam who was called upon to curse the children of Israel in the wilderness, but at the sight of them foretold their future greatness: "What I see for them is not yet; what I behold will not be soon: *a star rises from Jacob;* a meteor comes forth from Israel; it smashes the brow of Moab, the foundation of all children of Seth" (Numbers 24:17).

This prophecy was traditionally interpreted as pertaining to the Messiah, who would be like a star appearing in the Heavens and would gather the dispersed people of Israel to their home. The messianic overtones here are not just suggested by the opening part of this sentence, but also by the words with which Balaam preceded his prophecy: "Come, and I will announce to thee what this people [Israel] shall do to thy people [Moab] in the end of days" (Numbers 24:14).

Chagall's vision of the Western Wall, with its broad plaza and the exiles streaming into it, is thus not a portrayal of the reality of 1966, but of a future which he envisions as being, in Balaam's words, "not yet" and "not soon." As in his other works, he was combining here several ideas on Jewish nationhood—memories of the Second Temple, yearnings for a return to Zion,

and messianic symbols coupled with the seal of the modern State.

However, Chagall's vision has meanwhile been fulfilled. In June 1967, Jerusalem was reunited, and the Western Wall finally came under Jewish rule, as Chagall had hoped when he had pictured it under the seal of the State of Israel. Immediately on the heels of the first soldiers to reach the Wall was Chief Rabbi Goren, then Chief Rabbi of the Army, and one of the first things he did was to sound the shofar as an expression of triumph and thanksgiving. This manner of proclaiming Jewish rule was particularly appropriate, for under the British the Jews had been forbidden to sound the shofar at the Wall, even as part of the concluding service on Yom Kippur. Surely no one thought of the shofar being sounded above the wall in Chagall's mosaic, but they had materialized his vision in reality.

Furthermore, immediately after the end of the war, bulldozers began to clear a wide area before the Wall, tearing down the houses and opening up the narrow streets to create a large plaza to hold the thousands of pilgrims who would rush to Jerusalem for the subsequent Shavuoth holiday. Since then the plaza has been landscaped and developed and the Wall has been exposed much more during archaeological excavations, making an extended wall which closely resembles that in Chagall's mosaic. Although he had not dreamed of this when he created his "vision" of the future, almost his entire prophecy (albeit without the messianic over-

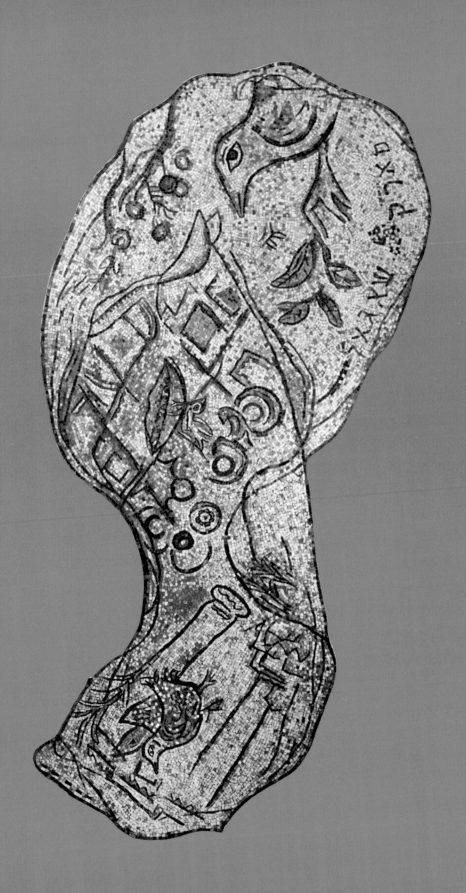

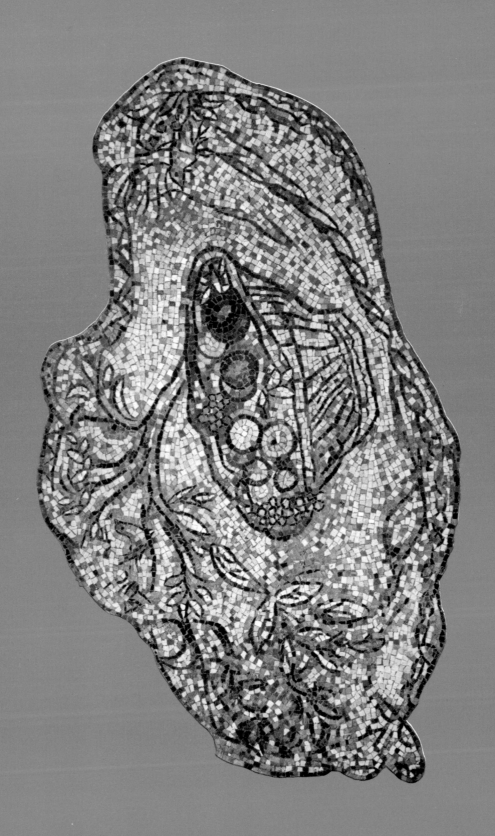

tones) was fulfilled in a remarkably short time to such an extent that the average spectator is amazed when he is told that Chagall designed the mosaic in 1966 and that it was executed before and not after the war which changed the face of Israel and Jerusalem.

COLOR, FORM, AND CONTENT

U P to this point, we have stressed the symbolism of Chagall's work in the Knesset, mentioning its formal qualities only in passing. But this side of the artist is of supreme importance and is well worth our careful consideration.

Chagall's Knesset decorations are done in what might be called his "late" style, which reached its full flowering in the 1950's as the artist entered his seventies. In many ways it resembles the late style of other painters who lived a long and continually fruitful life, such as Titian, Rembrandt, and Cezanne. All these artists became more "painterly" as they aged. The accent was repeatedly put on color harmonies and delicate nuances of tone rather than on outline, and the brushstroke became free and flowing, allowing color to blend into color without sharp transitions.

Chagall passed through many styles during his long development, influenced in turn by folk art and Russian icons, Fauvism, Cubism, Orphism, and Constructivism. He incorporated all of these elements into his own style, interpreting the formal discoveries of modern art not as their originators had intended, but as a means of conveying his own inner "psychic" reality. All these styles have left traces in his works, and even in the tapestries we suddenly come across passages which recall his Cubist period, such as the faceting of the

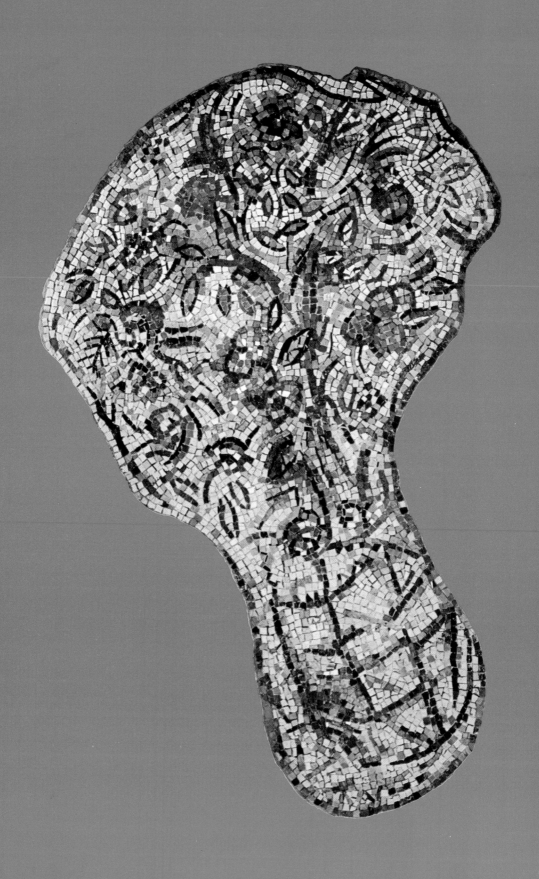

background of "Peace" or that around King David in the "Entry into Jerusalem," while Aaron's bright green face and David's green beard and blue hair in the "Exodus" show us how much he still has in him of the Fauve. In recent years his colors have developed from the sharp contrasts of the 1920's and '30's and the somber, often frightening clashes of the 1940's to delicate lyrical tones flowing over the surface of his canvases. His line, rather than limiting the color to a given object and acting as its boundary, has become almost independent, delineating the figure but allowing the color to escape beyond its "borders." This freeing of color from the confines of line was fostered by the large dimensions of the paintings Chagall has executed since World War II, which demanded a more sweeping line and a more fluid color than had hitherto been possible in his easel paintings.

This style was particularly appropriate to the large-scale decorations that Chagall was called upon to undertake at this time. For these commissions he developed a new planning technique in which he worked on his color and line compositions separately. First he would work out a general linear design in which the major motifs were sketched in freely. Then he would work out an abstract, balanced color composition and at the same time, but on other pieces of paper, a detailed drawing. Finally he would integrate the two, drawing his linear composition over the abstract color areas, so that the various elements harmonized, but did not necessarily exactly coincide. He would

then pick out the main figures in contrasting color accents so that they would stand out from this inter-related web of line and color. This manner of working can be seen in his sketches for the Hadassah windows and for the Paris Opera ceiling, both of which were designed before his works for the Knesset.

This technique gave Chagall several advantages in his decorative style, for, to be effective, a large decoration—a wall, a window, or a ceiling—must first of all be readable from a distance. Its colors and forms must be simplified so that the spectator immediately absorbs the main themes and so that his eye is led from one area to another by clear compositional rhythms both of line and of color. Secondly, a good decoration becomes part of the building it occupies, integrating with its architectural elements rather than clashing with them. Here, too, a large free composition will be more harmonious rather than one made up of small, contrasting areas which would divide the surface purposelessly. Finally, a decorative work creates an ambiance around the people living and working within the building it occupies, unconsciously directing the patterns of their lives, always present so that they can pause in their routine to examine the details, but never harshly intruding into their existence. Again, large areas of color blending into each other and covered with a fine line design exactly suit these needs.

These characteristics are all found in Chagall's Knesset works, where he literally took over a room, and by covering its walls and floor enveloped the

spectator in his own atmosphere. The State Room created, however, certain problems Chagall had not faced in his stained-glass or ceiling designs. The tapestries and mosaics were to be seen at eye level rather than from a distance. Chagall had earlier been upset at the effect his stained-glass windows had had at Hadassah, where they were set too low and too closely together, overpowering the spectator with their brilliant, sometimes almost clashing colors. Determined to avoid such an effect, Chagall chose more muted tones, only rarely allowing his palette to glow with the brilliant blues, greens, yellows, and reds he had used there. His colors were to enliven, but not to intrude; to decorate richly, but also to harmonize with the simple lines and open areas of the State gallery. Furthermore, each color scheme was selected to help express his subject, and to guide the spectator's eye from one scene to the next.

Chagall's new style is seen most clearly in the first of his tapestry designs, "Peace." The cartoon is predominantly green, and this color pervades most of the animals and figures in the painting, irrespective of their own local colors, skin and hair tones. He does not use a solid green, but one that changes continually from stroke to stroke, varying from earth green to brilliant bottle green to the most delicate pastel tones, and passing almost imperceptibly into many shades of yellow and gold. Against these greens, the major figures stand out in the complementary color, red. The mother and child in the lower left-hand corner, Isaiah, the flaming wings of the Holocaust angel, and the

grazing cow are all in red and orange tones, and these colors spill over into their surrounding areas, covering the root of Jesse and the animal and infant under Isaiah, as well as the crowd near Moses above the prophet. To this quiet composition, with its suggestion of the perfection of the circle, Chagall added touches of light blue, which were intensified in the tapestry so that they form, with the reds, a crowded frame enclosing the light and open vision. This spacious area, itself suggestive of the visionary quality of the scene, seems almost to project from within itself centrifugally the scenes and figures depicted around it and dependent on it.

From this tapestry, we are led through the strong diagonal of the mother to its continuation in the diagonal figure of Moses in the "Exodus." The transition is helped by the repetition of blues and greens in the Old Testament scenes on the right of the central tapestry. Once our eye is led to Moses, however, a new, dynamic composition takes over, directing us straight from Moses to David via the Exodus.

At first glance, the coloring of the "Exodus" seems not to conform with Chagall's late style, but to be more local, so that each object has its own colors, existing within strictly defined boundaries. But this is only seemingly true. The effect of the tapestry as a whole is a warm beige, and most of the colors used are shades of browns and golds, composed so as to join similarly colored individual figures into groups. While there are stronger blues and greens and even light purples winding through the composition, they are in muted

tones. The blues are used meaningfully to accent the figures of Abraham, God, Moses leading the people, and Aaron and the menorah at the bottom left. The only really sharp green, that of the angel guiding Israel, is used to emphasize a figure who would be otherwise ignored. The general impression is, however, of individual figures, each strongly outlined, who, together, form a crowd.

Chagall had a particular reason for this individualization. The overall beige background into which the crowd blends, and the almost white areas formed by Moses, the Tablets, and the Mount on one side and the "pillar of cloud" and barrier on the other side would have created certain patterns of vision which the artist wished to avoid. Our eyes would have stayed overlong on Moses receiving the Ten Commandments, the largest off-white area in the tapestry, and if they could have been induced to move at all, they would have jumped to the cloud and straight to David, bypassing the Exodus, the main theme, as though it was an entirely minor one. By breaking up the central mass of people into individuals, with a color composition which is nervous and pulls the eye from one figure to the next, he succeeded in leading our attention away from Moses, who is only one part of the story, and concentrating it on the main subject. Here, however, the direction of the crowd's motion, the constant drive to the left, and the drab, almost desert quality of the colors, forces our eyes to move through the crowd, taking in every detail, until we reach King David, the

only large intense area of color in the entire tapestry. His brilliant red robe and the Jerusalem of gold beside him become the goal of the entire composition, a rich and shining beacon toward which the poor, dusty wanderers strive continually.

From here, we are led almost immediately into the next tapestry, the "Entry into Jerusalem," by means of the repetition of King David in his brilliant red robe. This is the most colorful of the tapestries. David still stands out strongly, his redness underlined by the red bushes under him and the maroon and purple tones of the lower right-hand corner. These red-purples are used to accent other important parts of the composition. They are echoed, for instance, around the Israeli flag and the menorah at the left.

The other two major colors, blue and green, blend into each other, flowing over the figures and absorbing them into one intricate serpentine movement that expresses the joyful rhythms of music and the dance. Beginning with the musicians in the large blue area behind David, our eye is led up to the greens of the Ark and its accompanying figures, back down into the dancers, overflowing from them first down into the reapers and fruit carriers and then back up through the dancers and the two-headed man with a bow to the "Israel bird" at the top left. This musical motion of the dancing blue-greens, weaving through the painting, is penetrated on the left by the golds and yellows shining forth from Jerusalem, circled and lightly glowing at the top of the composition: the Holy City spreads

its bright light over the festivies celebrating the Entry into Jerusalem.

The three tapestries thus build up a cadence of color from the serene overall green of "Peace" through the teeming and parched beiges of the "Exodus" to the brilliant red and gold of David and Jerusalem, and finally swinging into the lively rhythms of the "Entry." Each tapestry preserves its own individual character and has reasons of its own for the way its color composition develops, but all three blend into a united whole which directs the spectator from one to the other along the gallery wall.

The same meaningful selection of form and color can be found in the mosaics. The floor mosaics are closest in color to the "Exodus," not only in the overall beige tonality and the harmonic combination of browns and ochres, but in the small but enlivening use of the blue-green as a contrast. The tones of the mosaic were chosen specifically to blend with the warm deep beige marble floor. Chagall did not wish his mosaic fragments to stand out too strongly against this floor, but rather to surprise the spectator wandering around the room who would "discover" them little by little. This goal lies behind the free scatter pattern of the twelve fragments, which crop up in constantly unexpected places and arrangements. In this way Chagall recreates the feeling of discovery felt when the remains of ancient synagogue mosaics were uncovered.

The light blue-green mosaic wall most closely resembles the composition of "Peace" and answers it across the

gallery. Here too the dominant color is varied, each stone being a slightly different shade of blue than its neighbor. This recalls the way Chagall builds up his brushstrokes one next to another, while the superimposed drawing is picked out in darker tones. These blues, which recall the blues of the sky seen beyond the nearby window, have been described by the artist as the colors of love and of peace. Against them, the brilliant golds and oranges of the menorah's flames gleam warmly, forming the type of contrast found in the reds of "Peace." Again, as in the earliest tapestry, the composition is circular. The eye is attracted to the heralding angel and led down through the crowd surging toward the wall to the wall itself and back up through the shooting star to the angel. All this revolves around the menorah at the center of the composition, the emblem and seal of the State, a vision hovering before the eyes of the spectator in an almost hallucinatory manner.

Thus the decoration of the entire room forms a unity which connects walls to floor, tapestry to mosaic, not by giving up the individual quality and character of each work, but by harmonizing and repeating compositions or colors across the room and carefully directing the viewer's eyes from one part of the decoration to the next.

Just as we may speak of the Knesset decorations as having been designed in Chagall's "late" style and as taking into consideration problems of decoration which had not previously interested him, so can we explain the comprehensive and involved iconographic program

with its clearly readable "message" which the artist evolved here. Undoubtedly, at some point in the long detailed explanation of Chagall's symbolism, the reader wondered how this type of program fitted in with the generally accepted view of Chagall as the dreamer of poetic and irrational fantasies, an artist who is often incomprehensible to the layman. We are acquainted with the enigmatic Chagall, who sees with his x-ray vision the calf in its mother's womb or the thoughts in the calf's mind and who paints figures floating through the air, standing as often on their heads as on their feet or having heads which are mysteriously disconnected from their bodies. On the whole, he seems to be someone more related to the theories of Sigmund Freud or the Surrealist poet André Breton than to the stories of the Bible. He has often refused to explain his work and has even denied that it has a literary content, preferring to allow the spectator to arrive at his own understanding through some form of communion with the painting. This means that he has not objected to the spectator misconstruing what he, the artist, was trying to express in his work, as long as the painting stimulated the viewer's imagination and elicited a personal response from him, which might, of course, differ from person to person. This attitude is so different from the approach shown by the artist in the tapestries and mosaics that one even wonders whether we can be talking of the same Chagall.

This accepted view of Chagall has, however, always ignored the fact that he is capable of clear thought as

well as of subconscious dreams. His ability to depict such thoughts is suggested in his illustrations of the works of Gogol and La Fontaine and, above all, the Bible. In his edition of Bible etchings and lithographs, he has even cited the words of the passages he illustrated, and his pictures always fit these words extremely well. Thus, his ability to think along purely rational lines would seem to be clear.

To understand this seeming dichotomy, one must penetrate to the very roots of Chagall's symbolism and discover there the existence of a vocabulary of personal symbols which are repeated from one picture to the next. In his earliest works, he had painted the Russian Jewish ghetto in which he had grown up, transforming peasants, farm animals, rabbis, and peddlars alike into symbols of his world. In Paris, before World War I, he added signs of the city, such as the Eiffel Tower, and, on returning to Russia and marrying Bella, in 1915, he developed a whole set of symbols of lovers to represent the joy of his new life, including the floating lovers, the eternally youthful bride, and the young dreaming artist. After his return to France in 1922, new elements were added: La Fontaine's animals, the French landscape, and the images of the Bible, especially those of the two men who most inspired him—Moses and David—whom he not only painted repeatedly but glorified in his poetry. Then came the crisis of World War II and the destruction of the major Jewish communities of Europe, which he symbolized through the tortured Jewish Christ and the

frightened, fleeing Madonna and Child. Bella's death, in 1944, increased his depression and added a new vividness to his dream of the eternal bride who dominates a good portion of his works from the 1940's.

By the time Chagall returned to France in 1948, his vocabulary of symbols was very large, and the various combinations he could create with it were innumerable. But these works of the late 1940's and 1950's were built up from so many different types of personal symbols that they remained enigmatically closed to a public unable to speak Chagall's symbolic language primarily because they were unfamiliar with the origins of each individual figure.

This Post-World War II period was also, however, the time of Chagall's monumental commissions and of his own large Bible paintings, his *Biblical Message,* in which he tried to epitomize man's relationship to God as manifested in the Old Testament and carried out later in Christ's martyrdom. In these Bible paintings, as in his decorations for the Church at Assy and the Cathedral of Metz, he built on his earlier Bible illustrations, just as in his other works he had built on his earlier collection of personal symbols. But there are two primary differences between his works based on the Bible and those in which he expressed only his own thoughts and feelings. First of all, there is no dictionary which we can use to decipher his personal symbolism, but his biblical works are based on combinations of his clearly labeled Old Testament illustrations, and the latter provide us with the necessary key to his symbolism.

Secondly, whereas in his private paintings he was not concerned as to whether or not the public understood him, in his biblical paintings and decorations Chagall had a message to convey, and he was vitally concerned that the same public this time understand him clearly. He wished to stir their imaginations not by plumbing the depths of their subconscious minds, but by allowing them to contemplate the full meaning and implications of his message. He therefore remained close to the original texts, adding his own element of poetry by his choice of scenes and by the manner in which he combined them.

It was during this period that he was invited to design the decorations for the Knesset. He fully understood that it was vital that the public be able to "read" and to identify with his message. He himself had had an emotional reaction first to the Holy Land and then to the State of Israel, becoming enthused by seeing a Jewish policeman, a Jewish farmer, or a Jewish cow, and he had had an equally emotional reaction to the Knesset invitation, offering his own work on the project free of charge to the State. If we combine this reaction to Israel, first with the enthusiasm engendered by belonging to a generation that can speak of the *end* of two thousand years of exile, then with his constant preoccupation with the fate of the Jewish refugee from World War II on, and finally add the ability he had developed in the last decades to formulate a clear biblical message, the type of symbolism he used in the Knesset becomes a foregone conclusion. He would

obviously choose events from the Bible for his main designs, scenes which every spectator—Jewish, Christian, or Moslem—would understand, and he would tie these events to those of the present and to his dreams of the future.

The choice of scenes remains personally Chagallian: the stars are Moses and David, Chagall's own heroes, and the major scene is the Exodus, the subject that has been worrying him since he fled Europe at the beginning of World War II and, returning after the war, found so many of his Jewish friends murdered. The joy of the return to Zion and the dream of eternal peace are not only appropriate to Jerusalem, but to Chagall's own longing for peace which he expressed in his poetry and speeches. The combination of past, present, and future, the removal of the boundaries of time along with those of perspective, and the revelation of the many levels of meaning an object can have within different contexts and because of different chains of associations are basic to Chagall's art as a whole. The main difference is that here the context is historical and religious rather than just personal. His wish for legibility does not, of course, stop him from turning figures upside down, combining animals and humans, and filling empty spaces with birds and two-headed goats, but all these Chagallian motifs are kept subservient to the main themes and to the artist's message.

The result is an ambiance that becomes itself an experience, one in which we can be impressed first by the beautiful formal quality of the art, then grasp

his main message, and then, Bible in hand, penetrate deeper and deeper into the artist's thoughts, emerging with ever richer and more fruitful interpretations of his work. In the end, we will arrive at a deep understanding not only of his art at the Knesset but of the greatness of this imaginative artist, who is also a thinker able to clothe his ideas in images that excite the imagination while carrying his message straight to the minds and hearts of the spectators.

The type for this book
was set by Union Linotypiste.
The book was printed
by Imprimerie Moderne du Lion
in December 1973.